Henri de Toulouse-Lautrec

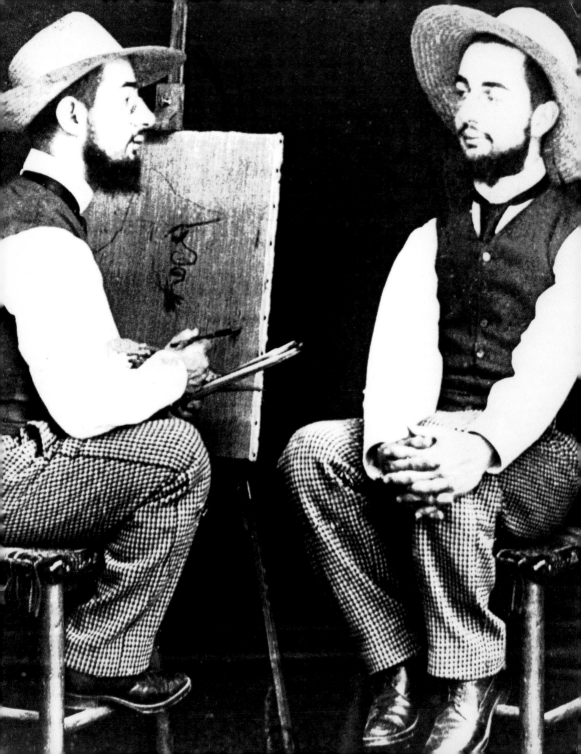

Udo Felbinger

Henri
de Toulouse-Lautrec

Life and Work

KÖNEMANN

Boyhood in Albi
Page 6

Arrival in Paris
Page 14

1864

1882

1892

1894

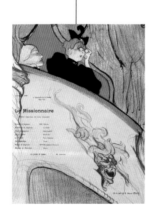

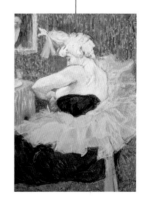

The Peak of Success
Page 48

In the Belle Époque
Page 60

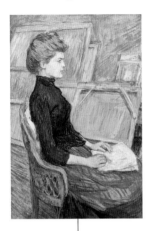
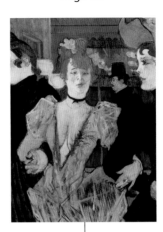

Boyhood in Albi 1864–1882

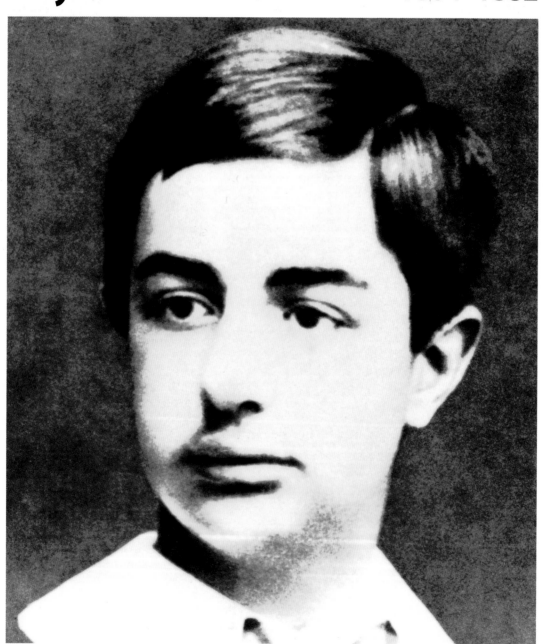

Born to an aristocratic family, Henri Toulouse-Lautrec manifested an extraordinary and precocious talent for drawing, as caricatures in his schoolbooks demonstrate. However, in his day professional artists were decidedly rare in families of this rank, and presumably Henri was meant to follow family tradition and take up a military career. However, his poor health and leg fractures in 1878 and 1879, which failed to heal properly, restricted young Henri's freedom considerably, prompting his mother to foster her son's artistic talent.

Initially, Toulouse-Lautrec began to study subjects from his immediate environment, making drawings or small oil paintings. His first teacher, the deaf-mute animal artist René Princeteau, convinced his parents to allow their son to train as a painter. Henri de Toulouse-Lautrec's interest in living things, in the restless and momentary, was already evident in his early works, with scenes of horses, riders and hunting. In his self-portraits, he began to establish an individual personality.

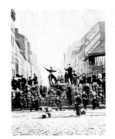

Barricades in Paris, 1871

1870–71 Franco-Prussian War, followed by Paris communes.

1871 Bismarck becomes first Chancellor of the German Reich (until 1890). Birth of Rasputin, Russian monk and Tsarist favorite (murdered 1916).

1874 Monet's *Impression - soleil levant* exhibited for the first time.

1877 First Wimbledon tennis championship.

1879 Edison invents the light bulb. World exhibition in Sydney.

1880 Zola publishes the novel *Nana*.

Toulouse-Lautrec as a small child, 1867

1864 A son, Henri-Marie-Raymond, is born to Comte Alphonse-Charles de Toulouse-Lautrec-Monfa and Comtesse Adèle-Marquette Tapié de Céleyran in the family's town house in Albi on November 24.

1878 Toulouse-Lautrec breaks his leg for the first time, getting up from a chair.

1879 In August, Henri falls into a ditch and breaks his right leg. As a result of these accidents, both legs subsequently stop growing, and Toulouse-Lautrec therefore remains stunted.

1881 In July, he fails the baccalauréat in Paris, but makes up for it in Toulouse in November.

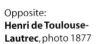

Opposite:
Henri de Toulouse-Lautrec, photo 1877

Right:
Henri's school exercise book, 1878
Albi, Musée
Toulouse-Lautrec

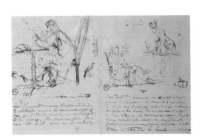

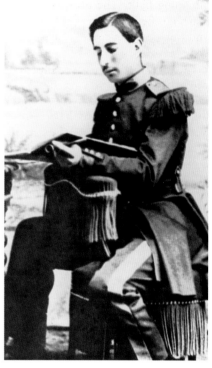

Childhood and Family

Both sides of the Toulouse-Lautrecs were descended from the most ancient of French noble families. Born in the family house in the center of Albi, Henri passed his early childhood at the Château du Bosc in Albi and the Château de Céleyran near Narbonne, where he had lessons in riding, Latin and Greek. After the death of their younger son Richard in 1868, the parents separated. After the Franco-Prussian War of 1870–71, the family settled in Paris.

Henri's artistic impulses expressed themselves in drawings and carica-tures in his exercise books even while he was still at the Lycée Fontanes. By the time he returned to Albi in 1875, he had already begun painting in oil. Two broken legs in rapid succession in 1878 and 1879 failed to knit together properly because of an inherited bone weakness. This was why Toulouse-Lautrec never grew more than 1.52 m tall and for the rest of his life needed a stick to walk. The family found it difficult to cope with this misfortune, as the sole surviving son was henceforth excluded from numerous aristocratic activities, such as a military career, hunting and

Top left:
The mother, Comtesse Adèle-Zoë-Marie-Marquette Tapié de Céleyran, photo

Top right:
The father, Comte Alphonse-Charles de Toulouse-Lautrec-Monfa, photo

The father, an eccentric loner, was always a dominant model for the son, who said of him: "When you meet Papa, you can be sure you won't be the most remarkable person there."

attending balls. The prospects for a marriage befitting the family status and thus the continuity of the family were likewise markedly dimmed. Because he was an only child and needed a lot of care and attention, his mother remained from early childhood the person he related to most.

His father, Comte Alphonse de Toulouse-Lautrec, was a known eccentric and kept the family permanently on the move, which meant that Henri's education was patchy. His father adored fairground shows and circuses, and even as a child Toulouse-Lautrec probably came into contact with the world of the stage and circus, which later so fascinated him. A hunting friend of his father, the deaf-mute animal painter René Princeteau, recognized Henri's extraordinary artistic talent and advised the parents to foster their son's talent.

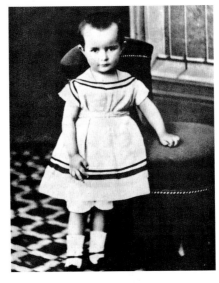

Little Henri in 1867, at the age of three, photo

Henri was affectionately called Petit Bijou (Little Jewel) by those around him. As was the fashion at the time, boys and girls were dressed the same up to the age of four, and Henri wears a dress with a long, frilly undergarment.

Toulouse-Lautrec's native city, Albi, photo ca. 1880

In the background are the Gothic cathedral and Palais de la Berbie, where the Musée Toulouse-Lautrec opened in 1922.

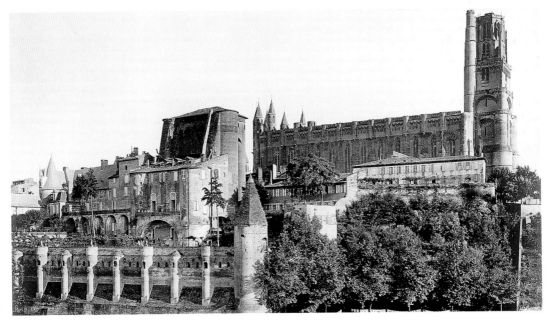

Early Works

Henri de Toulouse-Lautrec's extraordinary artistic gift became evident at the age of only 11, when, following the example of both his paternal uncles, he began to paint in oils. His pictures depict hunting themes and riding scenes, inspired by the aristocratic life-style of the family and his childhood in the country.

His training from 1878 by the animal painter René Princeteau, was undoubtedly a further reason for the choice of subjects. Thanks to Princeteau, Toulouse-Lautrec made first contact with life in a studio and met other painters. It is clear from the early paintings that Princeteau had familiarised his pupil with the art of the romantic painter Eugène Delacroix (1798–1863). The latter's historical scenes and animal paintings in dynamic, vivid colors had made the artist well-known and extremely popular among a broad public. The paintings deal in part

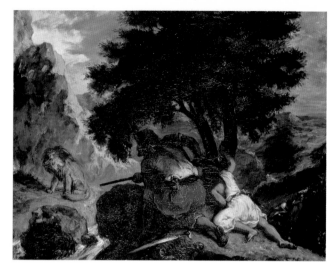

Eugène Delacroix, **Lion hunt in Morocco**, 1854 Oil on canvas 74 x 92 cm St. Petersburg, Hermitage

The Hôtel du Bosc in Albi, birthplace of Henri Toulouse-Lautrec, photo

with small-scale scenes of animals fighting, based on impressions from a trip to the East.

The restlessness and vivid colors typical of Delacroix and his followers recur in Toulouse-Lautrec's picture of his father out falconing. The subject matter possibly comes from a photo of his father falconing in Scots dress. The oil painting shows it translated into a riding scene in the technically difficult extended-portrait format, an achievement of astonishingly accomplished artistry for a student artist.

Because of the narrow pictorial space, the figure is cut close, with the intensity of coloration and relaxed brushwork reinforcing the effect of momentariness, a snapshot of life. These were qualities that would become predominant in later work.

It is clear from the picture that Toulouse-Lautrec was still developing and was trying out different

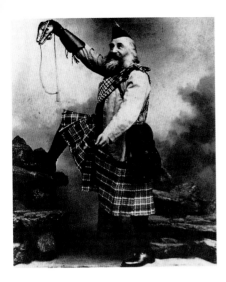

Comte de Toulouse-Lautrec as a falconer in Scots dress, photo

The father's delight in dressing up later surfaced in Henri.

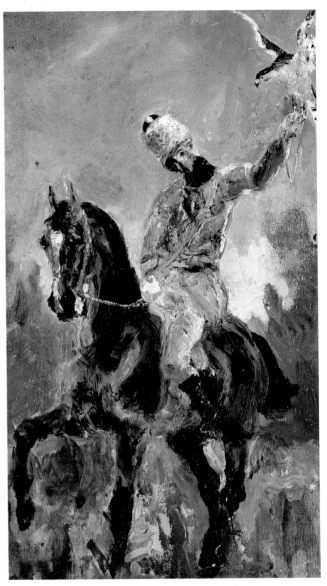

painting techniques and subjects. In this connection, it is significant that Toulouse-Lautrec never went to an art school, his training being exclusively within the confines of an artist's studio. Whereas art schools of the time placed great emphasis on anatomically correct drawings made from plaster sculptures or nude models, Toulouse-Lautrec manifested a clear preference for subjects in motion, as provided by nature. Conditioned by his disability, he was especially fascinated by this aspect. In Toulouse-Lautrec's artistic perception, painting is not about directly reproducing what exists but about interpreting reality.

Comte de Toulouse-Lautrec as a falconer, 1881, oil on wood 23.4 x 14 cm Albi, Musée Toulouse-Lautrec

The painting shows the father in oriental dress at the start of the hunt. The relaxed brushstroke and beautifully caught movement give rider and horse a very lively appearance.

Artistic Vocation

The ability to translate what they saw into pictures was already developed in Toulouse-Lautrec's family, because both the father, who fashioned animal sculptures in plaster, and his brother had a talent for drawing. As Henri's grandmother remarked: "When my sons kill wild fowl, the pleasure is threefold – wielding their shotguns, their pencils and their forks."

In 1880, military maneuvers near the Château du Bosc provided

Groom with two horses, 1880
Oil on card
32.5 x 23.8 cm
Albi, Musée Toulouse-Lautrec

When he took up art, Henri de Toulouse-Lautrec found plenty of subject matter in his immediate environment. What interested him in this picture is showing animals from different angles.

Toulouse-Lautrec with a wealth of new subjects to paint: men in widely diverse uniforms, horses and coaches. Where previously he had sought subjects within the family circle, he now began to record his environment. A typical feature of his style – pronounced bottom-view – was already evident. The artist's stunted growth and disability usually forced him to work seated.

As in the picture of the groom and two horses, Toulouse-Lautrec had already completely mastered the techniques required to show horses from different angles. The importance of figure representation for the young Toulouse-Lautrec is proved by a statement to his school friend Joyant: "… only the figure exists; the landscape is just an accessory and cannot be anything else; it merely serves to make the nature of the figure clearer." In this, he stands apart from the Impressionists such as Vincent van Gogh and Claude Monet, who focused intensively on depicting landscape and less on the human figure. The main interest of the Impressionists lay in investigating various light effects on objects rather than in depicting figures.

As the *Self-portrait in a mirror* (1882–83) shows, it was a time when Toulouse-Lautrec was exploring his own personality. By placing objects between him and his mirror image, he distances himself both from himself and from the observer. The strained, almost desperate gaze betrays much of the effort that standing and every movement cost him, and the bitter

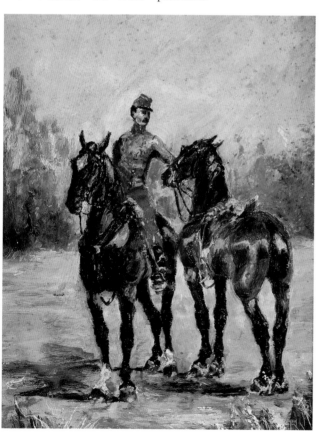

recognition that not he but his illness would determine his life. The self-portrait shows that the bitterness became part of his personality – despite Toulouse-Lautrec's cheerful temperament, the disability was to hang over him like a shadow all his life, a shadow he sought to dispel through self-mockery.

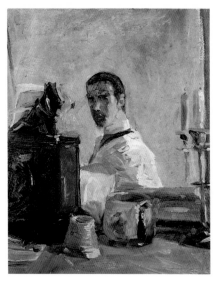

Self-portrait in a mirror, ca. 1880
Oil on card
40.5 x 32.5 cm
Albi, Musée Toulouse-Lautrec

Toulouse-Lautrec paints himself standing in front of a mirror with a gilt frame. His face is framed by a candlestick, pottery and a mantel clock. Gray tones and the serious facial expression create a melancholy mood.

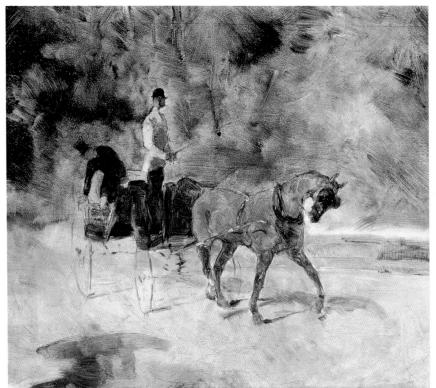

Dog cart, 1880
Oil on canvas
27 x 35 cm
Albi, Musée Toulouse-Lautrec

This picture shows Toulouse-Lautrec experimenting with brush techniques. The two figures are executed with fine strokes, while the surroundings are done in broad, counter-posed strokes. Despite the seemingly dashed-off execution, the road, pond and wood in the background are all recognizable. The technical and compositional skills in this picture are remarkable for a 16-year-old artist.

Arrival in Paris

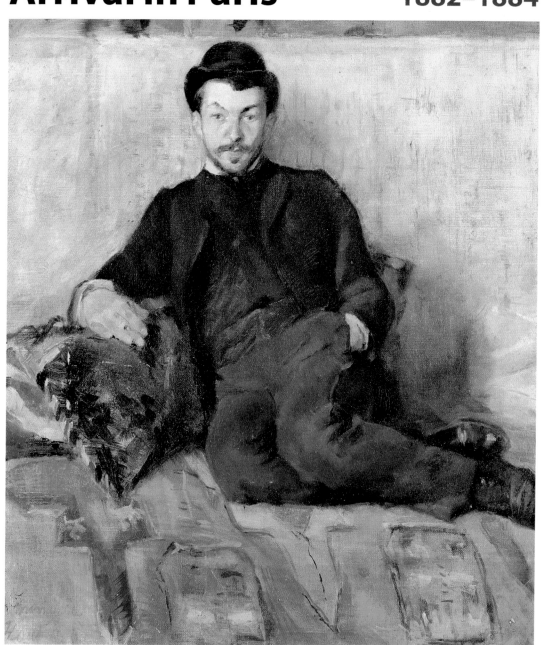

At René Princeteau's advice, in March 1882 Toulouse-Lautrec entered Léon Bonnat's studio. The move expanded the young painter's artistic horizon. In the metropolis, he had a chance to keep up with the latest artistic fashions and exhibit his pictures in cafés and cabarets. Toulouse-Lautrec put to canvas both the busy city streets and scenes of night life.

Initially, his interest in movement and color was cramped by the conventional artist's training of life classes in Bonnat's studio – Bonnat accepted Toulouse-Lautrec's oil paintings but rejected his drawings. In the end, Toulouse-Lautrec's passion for topical subject matter prevailed; fascinated by night life, he began to record his impressions in drawings on the spot, working them up later in paintings.

Robert Koch, ca. 1880

Toulouse-Lautrec ca. 1884

1882 Grave economic crisis in France. Robert Koch discovers *bacillus tuberculosis.* Triple alliance between Germany, Italy and Austria. Birth of Franklin D Roosevelt, President of the USA from 1933 to 1945. World exhibition in Moscow.

1883 Robert Koch discovers the cholera pathogene. Death of Karl Marx and Edouard Manet.

1884 A standards conference in Washington results in the earth being divided into 24 time zones and the prime meridian being located at Greenwich in England.

1882 In March, Toulouse-Lautrec enters Léon Bonnat's studio.

1883 At Émile Bernard's prompting, Toulouse-Lautrec first sees pictures by Cézanne.

1884 His mother buys the Château de Malromé. Toulouse-Lautrec leaves the family and moves into a studio in the rue Tourlaque.

1885 Toulouse-Lautrec's pictures exhibited for the first time, in Pau, south of France.

Opposite:
Portrait of Gustave Lucien Dennery, 1883
Oil on canvas, 55 x 46 cm
Paris, Musée d'Orsay

Right:
René Princeteau
Henri de Toulouse-Lautrec at the age of 19,
ca. 1883
Oil on canvas, 46 x 38 cm
Albi, Musée Toulouse-Lautrec

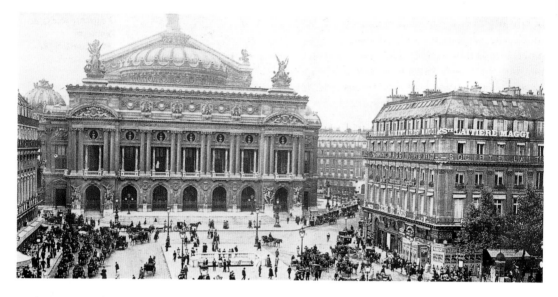

The Metropolis

Paris had changed rapidly since the mid-19th century. Baron Haussmann's radical schemes for demolition and rebuilding had created boulevards and spacious squares in place of the maze of narrow alleys. At important road junctions, the newly vacated sites were filled with major public buildings like the Opera House and the Grand Palais exhibition building. With their broad sidewalks, street cafés and busy traffic, the boulevards soon became the favored resort of all sections of the populace.

The tide of humanity and multitude of vehicles attracted the interest of artists, who elevated such everyday scenes to the subject matter of modern art. Architecture and art flourished. Besides the *Salon*, organized in the Louvre every year from 1863 as Europe's largest art exhibition, galleries and organizations sprang up offering facilities for exhibiting and buying works of art. Of particular note was the annual *Salon des Indépendants*, which from 1884 showed works that had been rejected by the jury of the official *Salon*.

With the world expositions of 1889 and 1900, Paris became more than ever the focus of international interest. At these, craft products and works of art were shown alongside technical innovations and industrial products, giving visitors the chance to compare developments in international art. Art critics lavished attention on the works shown and analyzed their quality, and their debates on the sense and purpose of art influenced public life to an extent hitherto unknown.

As a center of art, Paris therefore offered Toulouse-Lautrec a wealth

The first Metro station in Paris, photo

of stimuli for his own pictures. How much the scenes of city life fascinated him is indicated by *Dancers*, a picture from 1886. Like long-legged exotic birds, the ballet dancers advance on the viewer, who stands in front of a painted set on the stage. Behind the set, the head of another observer is visible. Clearly, the scene shows a new piece being rehearsed. Since the completion of the new Opera House designed by Charles Garnier in 1875, performances had attained a splendor never previously seen. For Toulouse-Lautrec, who was familiar mainly with the modest theaters of the provinces, the urge to capture the variety of scenes must have been irresistible. However, following Degas' example, he shows not the performance but only part of a rehearsal.

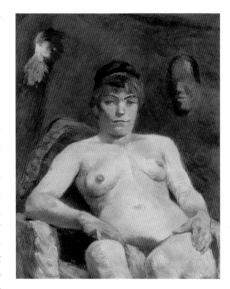

La grosse Maria, or Venus of Montmartre, 1884
Oil on canvas
79 x 64 cm
Wuppertal, Von-der-Heydt Museum

Surrounded by studio equipment, the model sits full frontally in an armchair. The generosity of the model's figure is conveyed with merciless realism. The ironic title makes a play on the traditional association of Venus and beauty, as a criticism of established art, because a Venus from the suburb of Montmartre cannot be a goddess of love and beauty in the traditional sense.

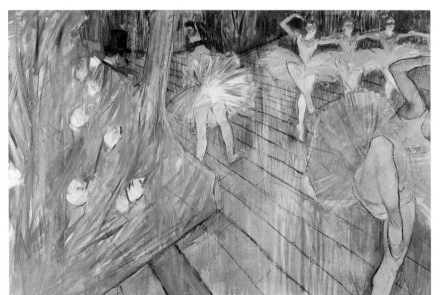

Dancers, 1886
Oil on canvas
102 x 152 cm
Stockholm, Thielska Galleriet

An unusual feature of this picture – whose subject matter displays parallels to Edgar Degas (pp. 36–37) – is the proximity of the viewer to the subject matter. A dancer cut off on the right and the boards receding far into the distance intensify the spatial connection.

The Student

Following Princeteau's advice, Toulouse-Lautrec left Albi to study painting in Paris. Then in March 1882 Henri Rachou, whom he knew from home, introduced him to the successful painter Léon Bonnat, who accepted him in his studio as a student.

In Bonnat's studio, Toulouse-Lautrec embarked on the systematic study of models, following plaster casts and life classes, initially with little success. He made up for the absence of appreciation from Bonnat by working harder. Then, in the same year, Bonnat closed his studio after being appointed professor at the College of Art in Paris, also because he wanted to spend more time on his numerous portrait commissions. Toulouse-Lautrec then entered the studio of the liberally-minded academic painter Fernand Cormon (1845–1924), where the young

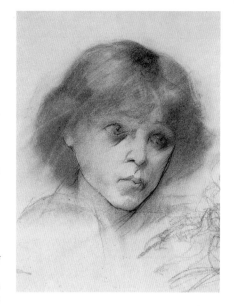

Head of young Severino Rossi, 1883 (detail)
Charcoal drawing
62 x 47 cm
Albi, Musée Toulouse-Lautrec

The portrait drawing of the young Rossi reproduces the gaunt features of a sickly-looking child. The facial features are recorded with lines, while the hair is depicted as a cloudy mass. The influence of the drawing technique learnt from life classes in Bonnat's and Cormon's studios is clearly evident.

In Cormon's studio, photo ca. 1885

student began drawing at life classes, again, this time to far greater appreciation from Cormon.

In a letter to his uncle Charles dated February 18, 1883, Toulouse-Lautrec writes: "Cormon's criticism is more agreeable than Bonnat's. He looks at everything you show him, and is enormously encouraging. You will be quite amazed, but I don't like that. My last teacher's tickings off really hauled me over the coals, and I didn't spare myself. Here I feel I'm on holiday and have to really pull myself together to do a decently thorough drawing, even though something worse drawn would do in Cormon's eyes. But a fortnight ago he did react and gave various pupils, including me, a dressing down. So I got down to work again full of enthusiasm."

However, drawing from a model who remained static did not accord

with Toulouse-Lautrec's artistic talents. His main interest lay in capturing movement and reproducing color (not in anatomically correct recordings of physical volume, which was the aim of life drawings). Following the example of fellow students in the studio dissatisfied with the training, he left Cormon's studio in 1884, though he would return in 1886. Toulouse-Lautrec moved to join his friends René Grenier and Henri Rachou in a summer house made available to them by the retired, art-loving Père Forest; in its garden numerous portraits were soon created (see page 30).

During this period, thanks to his friend and fellow student Emile Bernard, Toulouse-Lautrec got to know the pictures of the avant-garde, particularly Edgar Degas (see pages 36–37) and Paul Cézanne. Degas had become known mainly for his scenes from city life such as horse-racing and the theater, while Cézanne was

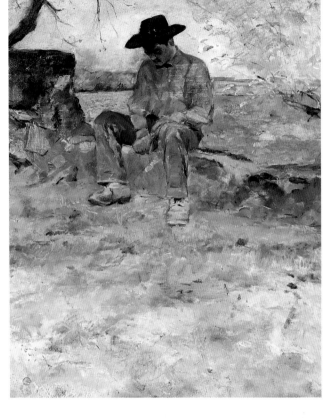

intensively preoccupied with painting still lifes and the landscape of the south of France. These two painters' views of art were still dismissed by the public of the day, so that it is all the more remarkable that they inspired the highly conservatively educated Toulouse-Lautrec.

Léon Bonnat
Job, 1880
Oil on canvas
161 x 109 cm
Bayonne, Musée Bonnat

This picture is an example of the history painting style officially accepted in Toulouse-Lautrec's day. The combination of the Biblical subject of Job appealing pitifully to God and a life drawing, conferred a special quality on the picture in contemporary eyes, because it united a religious message with technical execution of high quality.

Young Routy in Céleyran, 1882
Oil on canvas
65 x 49 cm
Albi, Musée Toulouse-Lautrec

The young agricultural worker Routy sits beneath the shade of a tree in the heat of the south of France, carving a stick. His absorption in his task makes him seem diffident, distancing him from his surroundings.

Like-minded Friends

Through the studio and his first showing in an exhibition in Pau in 1885, Toulouse-Lautrec got to know many other artists. Among his closest friends he numbered the painters Henri Rachou, René Grenier, Adolphe Albert, François Gauzi and Louis Anquetin.

Rachou, who painted him in 1883, would later, as director of the museum in Toulouse, try hard to acquire Toulouse-Lautrec's pictures after the latter's death. In Cormon's studio Toulouse-Lautrec also met Vincent van Gogh, whom he painted in a café. In early 1888 Toulouse-Lautrec advised van Gogh to continue his artistic studies of landscape and light in the south of France, advice which he followed.

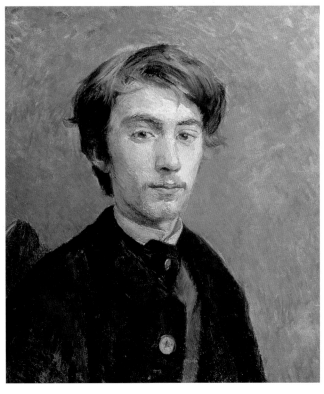

It had been a tradition in Paris since the 18th century for artists to paint each other's portraits, and Cormon's pupils followed suit. In particular, Toulouse-Lautrec's portrait of his progressively minded friend, Emile Bernard, shows great psychological empathy. Nothing in this plain portrait indicates that Bernard had to give 20 sittings before it was finished. At Bernard's prompting, in 1883 Toulouse-Lautrec first went to see paintings by Paul Cézanne, which greatly impressed him. However, in 1886 Bernard's artistic views led to a breach with Cormon, whereupon

Above:
Portrait of Émile Bernard, 1885
Oil on canvas
54.5 x 43.5 cm
London, Tate Gallery

Émile Bernard and Toulouse-Lautrec became acquainted in Cormon's studio in 1884. Like Toulouse-Lautrec, Bernard was also searching for new artistic forms of expression.

Left:
Toulouse-Lautrec as a choir boy, photo ca. 1886

Toulouse-Lautrec also left his studio temporarily.

A feature of the artistic life was fancy-dress balls, at which Toulouse-Lautrec always appeared extravagantly dressed up, e.g. as a choir boy, printing worker or oriental, as in the photo on page 20. Toulouse-Lautrec's inclination to mockery is evident in his parody of the *Sacred Grove* by the academic painter Puvis de Chavannes, which always hung in his studio.

Since summer 1884, the artist had been living with Grenier and his wife in the rue Fontaine. The Greniers introduced him to Parisian night life, which is why few works date from this time. Coincidentally Edgar Degas had a studio in the neighboring house, but Toulouse-Lautrec did not dare to speak to the master, who had a reputation for surliness. As Toulouse-Lautrec hated solitude, he constantly invited friends to supper or dropped in on them at all

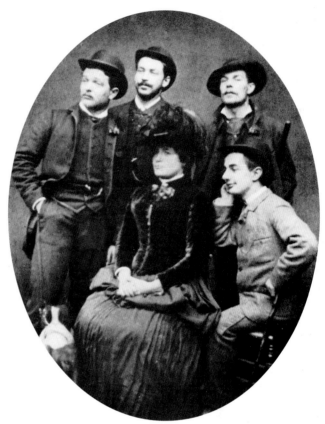

Above:
Toulouse-Lautrec with friends in Paris, photo ca. 1885

From left to right: René Grenier, Henri Rachou, Louis Anquetin, Lily Grenier and Toulouse-Lautrec.

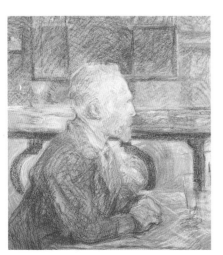

Left:
Portrait of Vincent van Gogh, 1887
Pastel
57 x 46.5 cm
Amsterdam, Stedelijk Museum

times of day and night. His humor, irony and sarcasm, which he clearly employed to overcome his disability mentally, made him an inexhaustible source of entertainment to his fellow men. He told a stranger who had praised his wit: "Monsieur, no one has done anything for centuries in my family. If I weren't witty, I'd be the ultimate dimwit."

Mother

Mama, only you! Dying is bloody difficult!

Last words of Henri de Toulouse-Lautrec on his death-bed

The most important person in Toulouse-Lautrec's life was his mother. After the failure of her marriage and death of her younger son Richard, a year after he was born, Henri occupied her time totally. Henri's accidents only proved to strengthen the bond between mother and son. She encouraged his painting studies, and after some hesitation paid him a regular allowance that enabled him to live a life free of financial worries. In the period which his mother spent in Paris, they sat down to a meal together almost daily. When they were geographically apart, they frequently wrote letters to each other. Adèle de Toulouse-Lautrec was a very educated woman, but modest in mien. As Toulouse-Lautrec's

Portrait of his mother, 1882
Charcoal drawing
62 x 40 cm
New York, Brooklyn Museum of Art

Left:
Toulouse-Lautrec with his mother Adèle in the garden of the Château de Malromé, photo ca. 1900

Portrait of Comtesse Adèle de Toulouse-Lautrec in the garden, 1882
Oil on canvas, 41 x 32.5 cm
Albi, Musée Toulouse Lautrec

schoolfriend Maurice Joyant describes her in his memoirs: "...his mother was an old lady with fine hands who went to mass every day." Her marked piety presumably helped her to cope with the numerous blows fate dealt her in life. When her son fell victim to syphilis and alcoholism and there was no longer any doubt as to his premature fragility, she spared no effort to stem his physical and mental decline. While she was tending her own mother in the south of France in February 1899, she learnt of her son's breakdown in Paris. In despair, she agreed to his admission to a sanatorium, a decision encouraged by Henri's favorite cousin, Gabriel Tapié de Céleyran, a student of medicine. Toulouse-Lautrec died in her arms two-and-a-half years later.

After his death, she looked after his artistic legacy and donated many works to the Musée Toulouse-Lautrec, which opened in Albi in 1922. She gave all his graphic works and numerous photos to the Bibliothèque Nationale in Paris.

The paintings and drawings for which she sat, betray much of the close relationship that linked mother and son. He painted her more often than anyone, and few of his other portraits are as intense as the pictures of his mother. The portraits on the garden bench and in the breakfast room of the Château de

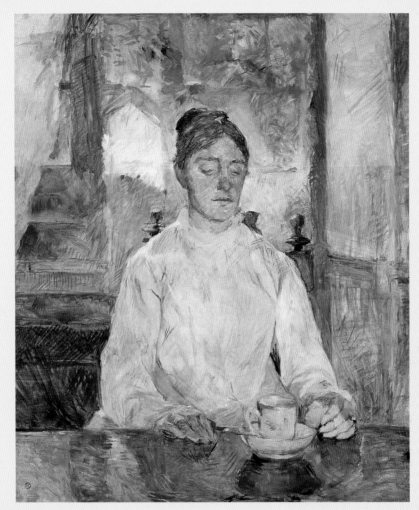

Malromé reproduce the almost resigned tranquillity with which the mother followed her son's life. His "sacred Madame Mère" as he called her, half-ironically, half-in admiration, constituted the sole calming influence in his unsettled life.

Portrait of Comtesse Adèle de Toulouse-Lautrec at the Château de Malromé, 1881
Oil on canvas, 92 x 80 cm
Albi, Musée Toulouse-Lautrec

Chronicler of Life

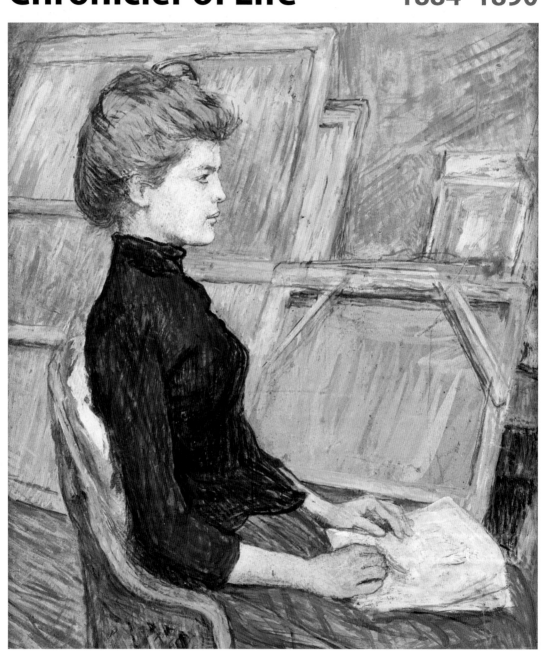

Realizing that he had nothing more to learn from academic painters, Toulouse-Lautrec turned enthusiastically to avant-garde art such as Edgar Degas's pictures. Degas had gradually become known for his scenes of city life, the theater, and horse-racing. Participation in several group shows such as the Group of 20 in Brussels in early 1888 indicated that Toulouse-Lautrec was interested in showing his art to a broader public.

A new technique using a lot of solvent in oil paint enabled him to create water-color effects in his pictures and fill the flatness of his compositions with movement by means of vibrant coloration. The success of his painting *Au Moulin Rouge – La danse* encouraged him to continue experimenting in this direction. Painting scenes of Paris's night life demanded a new artistic perception, which Toulouse-Lautrec worked on with feverish energy.

Contemporary photo of the Eiffel Tower

Toulouse-Lautrec ca. 1890

1885 Guy de Maupassant publishes his novel *Bel Ami*

1886 Statue of Liberty - a present from France - erected in New York harbor

1888 The 'Year of Three Emperors' in Germany

1889 Completion of the Eiffel Tower for the World Exposition

1890 Death of Vincent van Gogh. Kaiser Wilhelm II dismisses the German imperial chancellor Bismarck.
In England, outraged protest greets the publication of Oscar Wilde's novel *The Picture of Dorian Gray*. US cavalry massacre more than 200 Sioux Indians at Wounded Knee. Indians have henceforth to live in reservations.

1885 Toulouse-Lautrec exhibits his first works at Le Mirliton cabaret

1886 Becomes acquainted with Vincent van Gogh.

1888 Exhibits in Brussels with the Group of 20.

1889 Becomes acquainted with Edgar Degas. Theo van Gogh buys several pictures. 5th Salon des Indépendants opens on August 3.

1890 Becomes acquainted with Jane Avril.

Opposite:
Portrait of Hélène Vary, 1888
Oil on card, 75 x 50 cm
Bremen, Kunsthalle

Right:
Seated woman, rear view, 1888
Charcoal drawing, 62 x 48 cm
Albi, Musée Toulouse-Lautrec

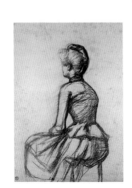

Montmarte – the Nocturnal Glow

After Toulouse-Lautrec had arranged for adequate financial support from his family, he began to follow the life of his fancy in Montmartre.

Montmartre was in transition from being a village to becoming a popular nightclub district, and its informality greatly attracted the 20-somethings. In the night-spots he often visited, Toulouse-Lautrec got to know the artists who appeared there, notably the dancer La Goulue, notorious as a creature of excess; his impressions are recorded in his sketchbooks. One of Toulouse-Lautrec's favorite bars was Le Mirliton (The Reedpipe), whose

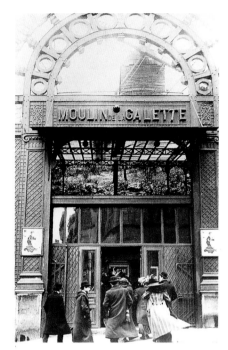

The Moulin de la Galette, photo ca. 1898

The photo shows the entrance to the Moulin de la Galette dance hall, which was in a barn beside a windmill (*moulin*) in Montmartre. The name came from *galette*, a type of pancake. The ball, which lasted from 3pm to midnight on Sundays, was popular with students and artists as much as with the bourgeoisie.

Quadrille around the Louis XIII chair, 1886 (detail)
Pen and pencil on paper
50 x 32 cm
Albi, Musée Toulouse-Lautrec

On this page from a sketchbook, which served as preparation for an oil painting of the same name and date, the artist has combined several scenes. Thus Inspector Roché, the 'Father of Modesty' (*Père de la Pudeur*) of the vice police, appears below a caricature – half fish, half human – in the right margin.

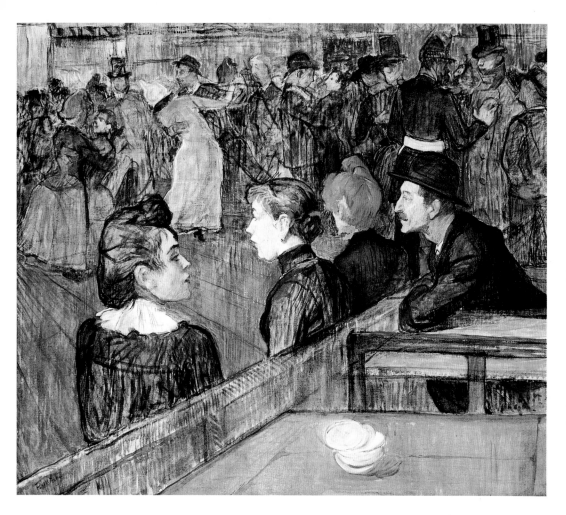

owner, Aristide Bruant, performed songs about prostitutes, pimps, and other social outcasts. The coarse Bruant held the artist in great esteem and hung up his picture *Quadrillle round the Louis XIII chair* in his cabaret. This was the first picture publicly exhibited by Toulouse-Lautrec.

Meanwhile, the Moulin de la Galette dance hall suggested Toulouse-Lautrec paint dance-hall scenes. At public balls, boisterous dance interludes such as the quadrille sometimes heightened the atmosphere to such a degree that the vice police intervened. To Paris's upper crust, these pleasures on the frontiers of legality were a great attraction, and their members were frequently seen mixing with the ordinary public.

Ball at the Moulin de la Galette, 1889
Oil on canvas
88.9 x 101.3 cm
Chicago, Art Institute

While the guests in the foreground at the ball await the next dance, the vice police are roughing up another guest.

Among the Bohemians

Removed from the aristocratic circle of his family, Toulouse-Lautrec was able to pursue his interests and passions undisturbed. He started to drink heavily and make frequent visits to brothels. Toulouse-Lautrec had, the knack of observing and chronicling the *demi-monde* milieu, which he accepted without snobbishness. The freedom from aristocratic and bourgeois standards of behavior that he could enjoy in Montmartre inspired him to depict typical scenes from low-class night clubs, a milieu that was initially unfamiliar to him. The drawings he brought back from his nocturnal prowlings were worked up the following day into picture compositions. This resulted in pictures that, for all their slice-of-life subject matter, were still precisely calculated and carefully executed.

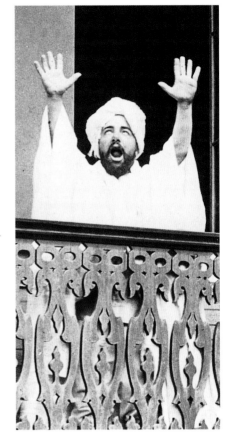

Right:
Toulouse-Lautrec as an Arab in mid-salutation from a balcony, photo ca. 1894

Toulouse-Lautrec's passion for dressing up is documented in numerous photos. Here he is parodying the Arab form of prayer, as though role-playing a muezzin and a prayer leader in a mosque.

Below:
In the garden of the Moulin Rouge, photo ca. 1890
Beside the stage stands a huge elephant made of *papier mâché*, a leftover from the world exposition.

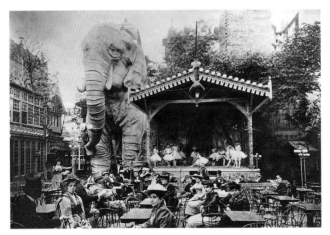

Individual faces and silhouettes stand out like portraits from the anonymous crowd of visitors to the cafés. Along with fellow artists of Henri de Toulouse-Lautrec, the faces frequently included dancers, comedians and singers who performed in the night clubs. A pose or particular physical feature of the figures in the picture was for Toulouse-Lautrec as much an expression of their individuality as their face. Thus Toulouse-Lautrec's father is recognizable in the right background of *Au Moulin*

Au Moulin Rouge - La danse, 1889–1890
Oil on canvas
115.5 x 150 cm
Philadelphia, Museum of Art

The eye slides between the back of a man and two women in the foreground towards Valentin le Désossé ('the Boneless') and La Goulue, who are doing a contredanse. The picture stands out for its extraordinary spatial and coloristic composition. While the horizontal band beneath the windows draws the onlookers together optically, the wall piers and foreground figures provide vertical stability. The alignment of the floorboards serve to draw the viewer's gaze directly into the scene. A greenish gas lighting illuminates the room, only the pink dress of the woman in the foreground, La Goulue's red stockings and the red jacket of a woman in the background providing touches of color, to underline the recession of the figures in spatial depth.

Toulouse-Lautrec over a glass of wine with La Goulue and Grille d'Égout. Photo ca. 1887.

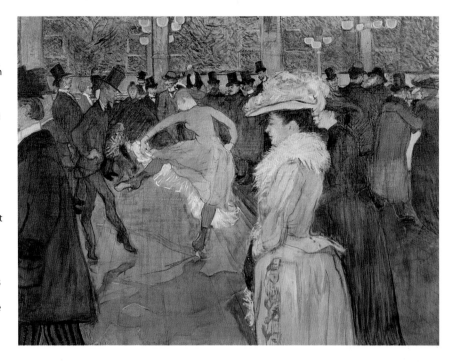

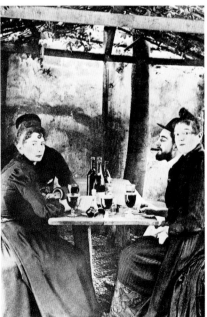

Rouge – *La danse* from his ample white beard. Whereas in the *Ball at the Moulin de la Galette* (page 27) painted in 1889 the main interest of the artist had been in the contrast between dancers and public, in *Au Moulin Rouge – La Danse* the emphasis is on a snapshot of carefully-arranged groups of figures. Thanks to the novelty of subject matter and the direct treatment of impressions of night life, this is one of Toulouse-Lautrec's principal works.

Looking at People

Toulouse-Lautrec painted many people from among his family and circle of friends. Whereas in his pictures of music and dance halls they often appear only as shapes in a crowd of people, in the individual portraits they have their own character. Basically Toulouse-Lautrec did two kinds of individual portrait: those where the subjects pose, and others where they are shown as though captured in a snapshot. In contrast to his teacher Bonnat, who painted severe-looking pictures of the public faces of Paris's upper crust, Toulouse-Lautrec painted his models just as he saw them.

The painter Suzanne Valadon, who had her studio in the same building as Toulouse-Lautrec, posed for him for *Rice powder*, a picture which Vincent van Gogh's brother, the art dealer Theo, later acquired for the Galerie Goupil. The serious mood of the picture betrays something of the tense relationship linking the two painters. Through her friendship with Edgar Degas and Auguste Renoir she exercised great influence on Toulouse-Lautrec. But continuous conflict with Valadon – she had even supposedly tried to trap him into marriage by feigning suicide – finally prompted Toulouse-Lautrec to terminate their relationship.

The picture of Toulouse-Lautrec's cousin and schoolfriend, the insurance agent Louis Pascal, shows a wholly different approach to portraiture, owing to Pascal's repu-

tation as a dandy. The subject is shown here in the studio, apparently on the point of leaving through the open door. One of the preliminary studies shows Pascal in a rear view. Presumably the artist wanted to

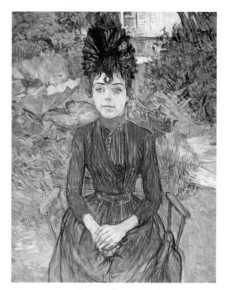

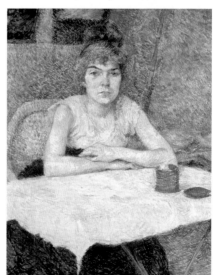

Portrait of Mademoiselle Justine Dieuhl, 1891
Oil on card
74 x 58 cm
Paris, Musée d'Orsay

Like numerous other portraits of this kind, the portrait of Justine Dieuhl was done in Père Forest's garden. The art-loving Père made his summer house available to many Parisian artists, and Henri de Toulouse-Lautrec also used the summer house for a while.

Portrait of Suzanne Valadon (Rice powder), 1888–1889
Oil on card
65 x 58 cm
Amsterdam, Stedelijk Museum

This is not a portrait in the usual sense, with the sitter as the focal point. Instead Toulouse-Lautrec combines the portrait with an atmospheric depiction of an interior. Various shades of white and the grainy structure of the background heighten the sense of an intimate snapshot.

Portrait of Dr. Bourges, 1891
Oil on canvas
78.7 x 50.5 cm
Pittsburgh, Carnegie Museum of Art

Toulouse-Lautrec painted his friend and flatmate Dr. Bourges, like Louis Pascal, in a corner of the studio but in a larger pictorial section, in the style of the society portraits of his teacher Bonnat, who mostly painted gentlemen in black suits full length. However, he does add a touch of informality by adding a Japanese scroll to the picture.

record his friend in a stance characteristic of him, and therefore did several studies until he had captured the essentials. For Toulouse-Lautrec, a person's physical bearing was an inalienable part of his individuality.

The fugitive image of a flying visit recurs in the portrait of his friend Dr Bourges, indicated in this case by the gesture of drawing on gloves, conferring on this picture – like so many in Toulouse-Lautrec's oeuvre – the character of a snapshot.

Portrait of Monsieur Louis Pascal, ca. 1891
Oil on card
81 x 54 cm
Albi, Musée Toulouse-Lautrec

Virtuoso of Line

To be able to record his impressions of Paris immediately, Toulouse-Lautrec always carried a sketchbook and pencil or charcoal. The ideas and subjects that he gathered every day in this way he later worked up in his studio as carefully executed drawings, which were then partly transformed into oil paintings. In the process, he experimented not only with the usual pencil or pen-and-ink techniques but also with the simultaneous application of diverse drawing media, such as oil and charcoal as in the scene *On the day of her first communion*. The scene shows a Parisian family taking their daughter to church on Low Sunday. Both the unusual quality of the event and its everyday nature find their counterparts in the unusual technique and the relatively conventional composition. Toulouse-Lautrec applied black and white oil paint on top of a linear framework of charcoal strokes. Combined with the effect of the colored card, an impression of three-dimensionality and spatial depth is produced. The figures are modeled in detail, but a few strokes suffice to depict the street corner.

Economy of graphic means combined with great immediacy is the mark of Toulouse-Lautrec's graphic technique. A drawing of quite a different nature shows Suzanne Valadon, the painter's girlfriend, sitting sullenly in a café. Here again Toulouse-Lautrec works with sparing contour lines to capture the vital elements of the scene, subsequently filling it out with hatching. Suzanne Valadon's silhouette stands out against the dark wall pilaster, which reinforces the attitude of aversion. The drawing was done shortly

On the day of her first communion, 1888
Charcoal and oil on card
63 x 36 cm
Toulouse, Musée des Augustins

before the two separated, and shows something of the antipathy they felt for each other.

Toulouse-Lautrec had the knack of using a brush like a drawing pencil. To be able to work more quickly, he had begun to experiment with thinned oil paints, which could be applied easily and without pressure and dried very quickly. This enabled him to work in a way normally possible only with charcoal or pastels, a combination of drawing and painting which is a typical feature of his style.

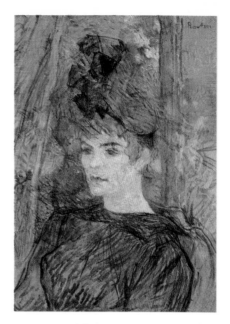

Suzanne Valadon, 1885
Oil on canvas
54.5 x 45 cm
Copenhagen, Ny Carlsberg Glyptotek

Toulouse-Lautrec's gift for using the brush like a drawing pencil is particularly evident in this portrait. The contours customary in drawings are largely dispensed with. Instead, Toulouse-Lautrec focuses on reproducing mood by a more careful modeling of the background.

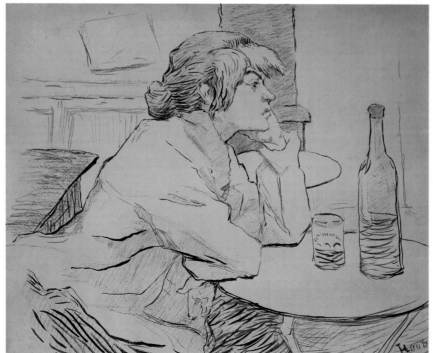

Hangover: the drinker (Suzanne Valadon), 1889
Gouache on card
49 x 63 cm
Albi, Musée Toulouse-Lautrec

The drawing was worked up soon after into a painting (Fogg Art Museum, Cambridge, Mass.) while retaining the spontaneous character. In the painting, Toulouse Lautrec filled the surfaces in the background with crescent-shaped brushstrokes, which heighten the aggressiveness of the situation.

Perfecting his Style

It had taken Toulouse-Lautrec an astonishingly short time to find his unmistakable personal style. Uninfluenced by his teachers in the choice of subject matter, he had opened up to painting a hitherto unknown freedom by importing the aesthetics of drawing, i.e. a method of representation dominated by line. His especial invention was oil paint strongly thinned, which enabled him to record rapidly his spontaneous impressions and lent his pictures their unique immediacy. This special feature was quickly recognized by his fellow artists.

The Belgian painter Theo van Rijsselberghe visited Toulouse-Lautrec's studio in 1887 and wrote to Octave Maus, secretary of the Group of 20 artists in Brussels: "The little short-legged fellow is not at all bad. The guy has talent! Definitely for the XX. Has never exhibited. Is currently doing some very amusing things: Fernando Circus, whores and all that. Knows the right people. In a word, the right sort! He found very chic the idea of exhibiting at the XX and being represented by some (brothel) scenes from the rue de Sèze and rue Laffite."

After Toulouse-Lautrec had first exhibited with the 20 in Brussels in 1888, he also exhibited at the 5th Salon des Indépendants in Paris in 1889. Joseph Oller, founder of the Moulin Rouge, liked the picture of *Trick Rider at the Fernando Circus* so much that he bought it and hung

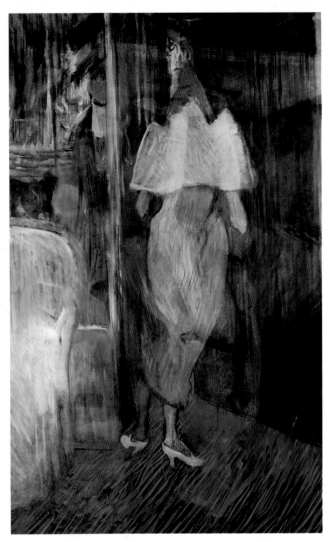

Lady in evening dress at the entrance to a theater box, ca. 1890, Oil on canvas, 81 x 51.5 cm Albi, Musée Toulouse-Lautrec

The picture shows the back of a woman who is leaving the box to join a man in the *salon*. The sense of mystery in the scene is emphasized by light effects produced with thinned oil paints. The scene is also notable for the diffuse sense of space and the fact that the woman's face is hidden from the viewer.

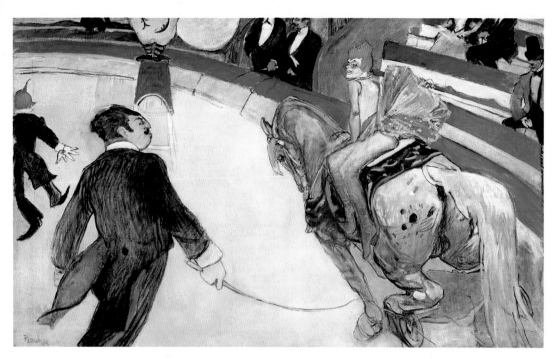

Trick rider at the Fernando Circus, 1887–1888
Oil on canvas
103.5 x 161.5 cm
Chicago, Art Institute

Sitting on the back of the galloping horse like a butterfly, the artiste flashes an ambiguous smile at the ringmaster to indicate her readiness for the next trick. The contra-rotating motions of the two figures confer a particular dynamic on the picture that casts a spell over the viewer.

it in his café. Toulouse-Lautrec's first large composition, the *Trick Rider*, already contains all the qualities of later pictures: flatness and movement are recorded in thinned paint, which lets the undercoat show through. Influenced by Japanese woodcuts, the artist emphasizes the chance nature of the slice of picture by cutting off the heads of the figures in a way unthinkable according to the accepted criteria of contemporary art. Specially emphasized by outlines, the figures stand out from the ground like silhouettes.

Familiar with the circus since childhood, Toulouse-Lautrec was particularly interested in the simultaneous movements of the clowns and artistes, which prompt the

viewer to gaze round the ring. He achieved this confusing effect in the viewer by cutting off the clowns with the picture frame. The circus thus becomes a symbol of the fragmentation of modern life, which can no longer be completely caught from a single perspective.

The general sense of uncertainty at the end of the century was reflected in the yearning for diversion, for an escape from the real world. This was the mood that Toulouse-Lautrec captured with his new form of representation.

Degas – an Artist to Follow

One of the most important influences on Toulouse-Lautrec was the painter Edgar Degas (1834–1917), who, like him, was born of a noble family. Degas is particularly credited with having been the first to draw the attention of painting as a whole subject matter from city life. In particular he went to café-concerts in the 1870s and set down his impressions in drawings. Degas's preferred drawing medium was colored pastel chalk, which he used to draw scenes in cafés, night-clubs, brothels and the theater. Because of their powdery effect and soft colors, pastel chalks are especially suited to reproducing fabrics and light effects. Studies of figures in bottom view and their special lighting effects, the passing detail caught as an impression, and the anonymity of the metropolitan public had received serious treatment in Degas's hands.

Inspired in part by the minimalist aesthetic and flat spatial presentation of Japanese woodcuts, Toulouse-Lautrec succeeded in further developing Degas's repertory of subjects and topics. He took Degas's trick of optical foreshortening a stage further, and by emphasizing the vertical endeavored to bind the composition to the pictorial

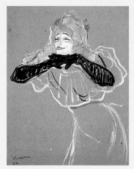

Yvette Guilbert sings 'Linger Longer, Loo', 1894
Oil on card
58 x 44 cm
Moscow, Pushkin Museum

Edgar Degas
The café-concert at Les Ambassadeurs, 1876
Pastels on monotype
37 x 27 cm
Lyons, Musée des Beaux-Arts

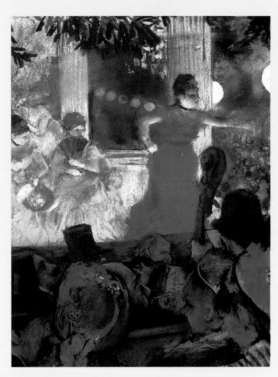

surface. In doing so, he lost much of the stability of figure still present in Degas. Just how formative Degas' perception of people and things was for the young Toulouse-Lautrec is evident from a comparison of a pair of nudes by the two artists. In his picture, Degas particularly emphasizes the constitution of the back and the play of light on the skin, shown in top view in an arrested movement in which the face remains averted. The anonymity and

top view recur in Toulouse-Lautrec, as does the play of light on the skin. The pictures share the impression of being details, extracts, which is the result of objects being cut off by the picture frame.

Likewise, Degas' café-concert picture displays the first manifestation of many features that would later recur in the works of Toulouse-Lautrec. The singer on stage lit from below is repeated in Toulouse-Lautrec's oil painting *Yvette*

Guilbert sings 'Linger Longer, Loo' of 1894. The crowded public, dim gaslighting and scroll of the double-bass recur in the *Jane Avril* poster (page 66), the double bass forming an important feature of the composition there. However, in contrast to the paintings of Toulouse-Lautrec, Degas's picture composition is relatively conventional, and does not contain the extreme optical foreshortenings typical of Toulouse-Lautrec. As a result of the powdery effect of the

pastel crayons, coloration and light effects differ markedly. In Toulouse-Lautrec the colors are more garish, the contrasts of light and shadow more pronounced.

Degas recognized Toulouse-Lautrec's gift at once and spoke of his drawings almost with envy: "Just to think a youth has done what we've taken all our lives to do." The initial esteem developed into sour rivalry, deliberately and openly fanned by Degas, who let fall disparaging remarks about Toulouse-Lautrec and his art, to the extent of mocking him in front of others. Alluding to his deformity, he is supposed to have said to Suzanne Valadon: "He wears my clothes, but cut to his size." The comment reveals the basic difference of temperament between the two painters: Degas's indifferent aloofness and striving for balance contrasts with Toulouse-Lautrec's interest in people and an unprettified reality.

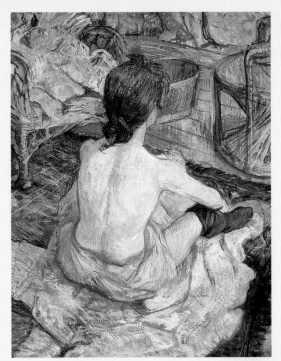

At toilette, 1896
Oil on card
67 x 54 cm
Paris, Musée d'Orsay

Edgar Degas
The Tub, 1886
Pastels
60 x 83
Paris, Musée d'Orsay

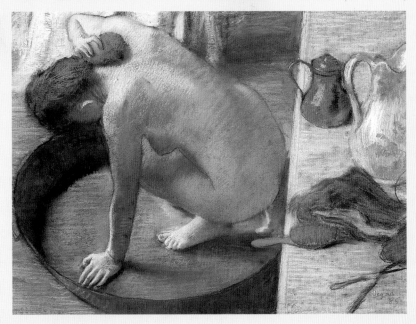

Overnight Fame 1891–1892

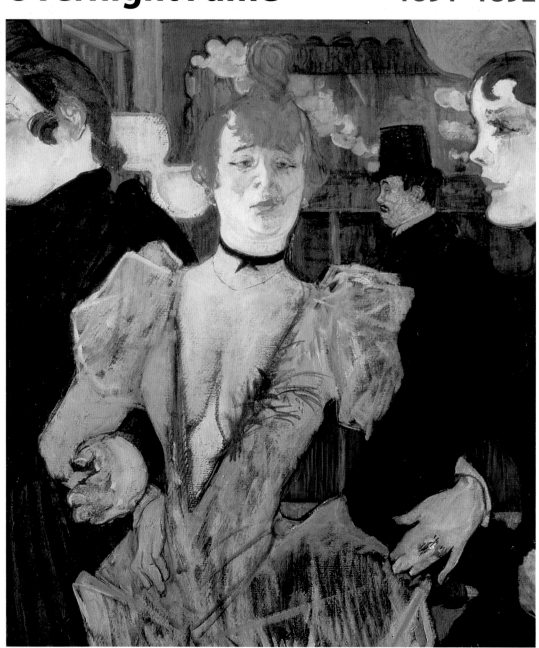

Thanks to his first poster for the Moulin Rouge, Toulouse-Lautrec became known to all Paris. He began to design further posters, also title pages and illustrations for periodicals. At the same time, he worked feverishly on oil paintings showing scenes from Paris's nightlife. Living with Dr. Bourges provideed some stability in his life, which otherwise was spent mainly in the studio and night clubs. His fatal fondness for strong liquor could not be checked even by his cousin Gabriel Tapié de Céleyran, who dogged his heels like a shadow. Toulouse-Lautrec's love affairs with artistes of cabarets and café-concerts alternated with frequent visits to prostitutes. During this period, the 30-year-old painter worked like a demon, to pour the abundance of his observations into his art.

Statue of Liberty in New York

Toulouse-Lautrec, 1892

1891 Death of the poet Arthur Rimbaud. Debussy composes *Après-midi d'un faune.* Telephone service set up between Britain and Germany. Work begins on construction of Trans-Siberian Railway.

1892 Claude Monet begins his cycle of paintings of Rouen Cathedral. New immigration handling center opens on Ellis Island, New York.

1891 Toulouse-Lautrec and his friend Bourges move to 21 rue Fontaine (until end of 1893). He designs his first poster for the Moulin Rouge dance hall, commissioned by its owner Charles Zidler. In October, the Natansons establish the *Revue Blanche* periodical, for which Toulouse-Lautrec designs a poster (page 74).

1892 Toulouse-Lautrec shows some pictures at Les XX and the Salon des Artistes Indépendants, also prints of the *Moulin Rouge* poster.

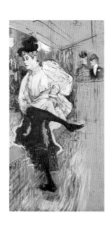

Opposite:
La Goulue enters the Moulin Rouge with two women, 1892
Oil on card, 79.4 x 59 cm
New York, Museum of Modern Art

Right:
Jane Avril dancing, 1892
Oil on card, 85.5 x 45 cm
Paris, Musée d'Orsay

deville Glitter

Toulouse-Lautrec was a confirmed regular at the Moulin Rouge soon after it opened, sitting and drawing there all night long. The rapt expressions of the subjects in *At the Moulin Rouge: two women waltzing* introduces a more personal note into the cabaret and music hall pictures.

The outward isolation of the figures is made still clearer by the way Toulouse-Lautrec depicts their surroundings. Where previously onlookers had been anonymous, they are now enriched with details and individual faces, thus losing their background character. Toulouse-Lautrec's growing familiarity with the café and its visitors is marked.

The diversity of things to draw that the Moulin Rouge offered him is proved by the next major work, *In the promenoir*. The *promenoir* was a covered walk around the dance floor

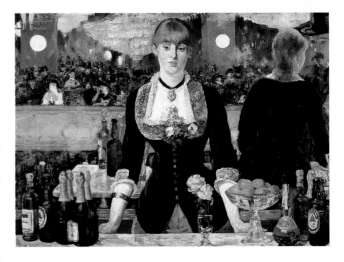

Edouard Manet
Bar at the Folies-Bergère, 1881–1882
Oil on canvas
90 x 130 cm
London, Courtauld Institute Galleries

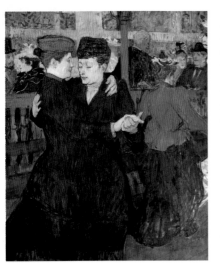

In the Moulin Rouge: two waltzing women, 1892
Oil on card
93 x 80 cm
Prague, Národni Galerie

Their embrace fuses the two waltzing women into a single dark silhouette. Their position in the left half of the picture opens up a view towards the public, and emphasizes the sense it is an extract from a larger scene.

where people could stroll round, sit down, fetch drinks or just watch what was going on.

Almost everyone in the picture can be identified, so that, for this reason too, the work occupies a special position in his oeuvre. Toulouse-Lautrec is seen in profile beside his cousin and constant companion Gabriel Tapié de Céleyran. In front of a mirror in the right background stands the dancer La Goulue prinking her hair, watched by her friend Môme Fromage, who also danced at the Moulin Rouge. At the table in the foreground some of Toulouse-Lautrec's friends are seated: the influential music critic Edouard Dujardin, Macarona the dancer, the photographer Paul Sescau, who photographed Toulouse-Lautrec several times, and the champagne dealer and roué Maurice Guibert. May Milton, a dancer at the Moulin Rouge (page 51), appears in the right foreground, the lighting giving her

face the appearance of an eerie mask.

The simultaneity of sundry actions and the effect of artificial light are reproduced more delicately than in earlier pictures. In this almost shadowless world of light, everyday laws do not apply. The distancing effect had already engaged the attention of Edouard Manet (1832–1883) in *Bar in the Folies-Bergère*, but there the frontal representation causes the subject to stand out clearly. In *Promenoir*, Toulouse-Lautrec condenses the surroundings into an atmosphere that almost envelopes the figures.

In the promenoir of the Moulin Rouge, 1892
Oil on canvas
133.5 x 141 cm
Chicago, Art Institute

The right edge of this picture was cut off by Toulouse-Lautrec's executors, but stuck on again in 1914.

Moulin Rouge

It was fun. I had what was for me a quite new feeling of authority over my whole studio.

Henri de Toulouse-Lautrec about his first poster

One of the first posters that Toulouse-Lautrec designed was an immediate and total success. The famous poster-artist Jules Chéret had already supplied a design for the Moulin Rouge (page 44), which opened on October 5, 1889. Toulouse-Lautrec's design clearly stands apart from other posters, not least in the particular use of the capital M and attached triple script in signal red. Prompted by *Au Moulin-Rouge – La Danse* of 1889–1890 (page 29), Toulouse-Lautrec had moved the two stars, La Goulue and Valentin de Désossé, who for a while performed together at the Moulin Rouge, into the foreground of the poster. What was radically new in this composition was the arrangement of three stylized silhouettes, which generates a vortex of optical depth even stronger than in the painting. In comparison with the preparatory study, it is striking that, in the poster, the audience has merged into a single silhouette, creating greater unity than previously. La Goulue (Greedy Girl) (1870–1928), whose real name was Louise Weber,

Henri de Toulouse-Lautrec in front of the painting of *La Goulue* **(the Greedy Girl) and Valentin (the Snake Man)**, photo ca. 1891

came from Alsace and had originally been a laundress. She got her name from her habit of draining guests' glasses. As she consequently put on weight, she was soon unable to dance the whole performance and lost her job. She later appeared as a belly dancer in a fairground show, for which Toulouse-Lautrec painted two streamers in 1895. Valentin le Désossé (1843–1907) – known as the Snake Man – was the tenant

of a wine store and considered the doyen of the waltz in every dance hall in Paris. His gaunt frame and enormous agility turned him into an institution of Paris's night life.

La Goulue (the Greedy Girl) and Valentin (the Snake Man), 1891
Charcoal and gouache
154 x 118 cm
Albi, Musée Toulouse-Lautrec

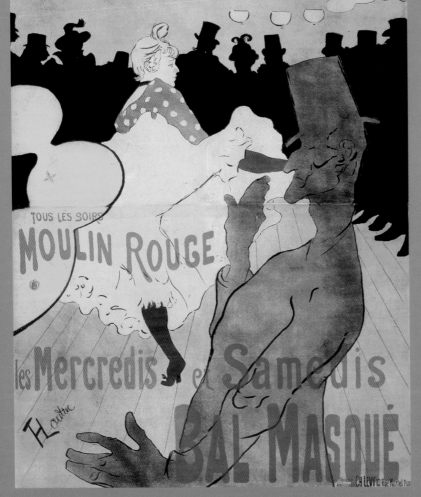

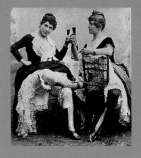

La Goulue and Grille d'Égout, photo ca. 1890

Moulin Rouge: La Goulue, 1891
Lithograph in four colors (poster)
67 x 54 cm
San Diego, Museum of Art

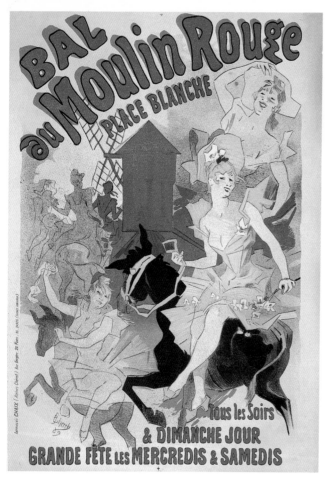

Jules Chéret
Bal au Moulin Rouge,
1889
Color lithograph
(poster), 61 x 42.8 cm
New Jersey, Jane
Voorheers Zimmerli
Art Museum

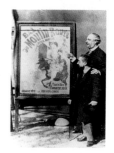

**Toulouse-Lautrec
with Charles Zidler
in front of the** *Moulin
Rouge* **poster by
Jules Chéret**,
photo ca. 1892

Poster Art –
a New Medium
is Discovered

Towards the end of the 19th century, there was huge growth in industrial production and consequently in advertising as well. With their color and design, posters proved to be the best method of drawing attention to products and functions. The tech-nology of lithography provided good value – long print-runs meant wide distribution of this 'street art'.

Whereas earlier posters printed as lithographs had mostly been designed by conventional graphic artists, in the hands of the painter Jules Chéret (1836–1932) they were given proper artistic treatment for the first time. In 1877 Chéret designed the first poster without perspective or shadow, for the Folies-Bergère music hall. This was the beginning of a development which took posters away from specific representations of reality by using color surfaces more purpose-fully and simplifying forms.

With his artistically innovative poster for the Moulin Rouge, Toulouse-Lautrec trumped Chéret, and as he swept on, he simplified the representation even further. His poster for the comedian Caudieux is highly sophisticated in its simplicity of color and form. Caudieux's silhou-ette, black outlined in green, darts past the viewer, thus giving an impres-sion of the speed of his patter and his humor. The mincing step – empha-sized still more by the diagonal boards of the stage – and the puck-ishly twisted mouth with its red lips

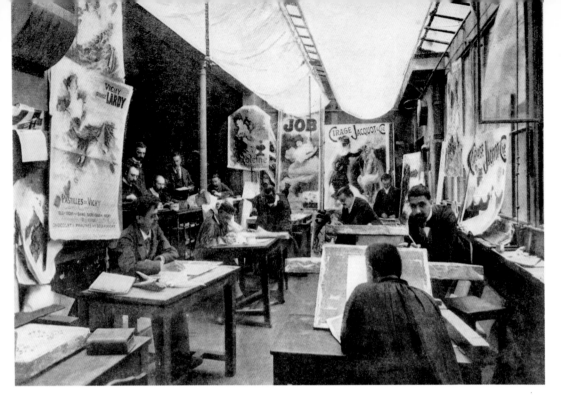

Inside Jules Chéret's studio, photo ca. 1892

were portrayed with precision, to capture the essence of the comedian. With the figure cut off by the frame, Toulouse-Lautrec again creates an impression of momentariness, as in his great compositions.

These formal innovations gave poster production, hitherto considered an inferior craft, a leg up to the status of a modern graphic art. Thanks to Toulouse-Lautrec's updating of poster design, the borders between art and advertising began to blur, effectively upgrading poster art.

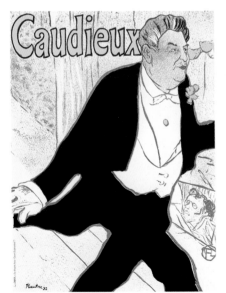

Caudieux, 1893
Lithograph in four colors (poster)
130 x 95 cm
Paris, private ownership

The poster for the comedian Caudieux, who was called *homme canon* (Cannon Man), is a good example of Toulouse-Lautrec's perception of space and movement. The strong emphasis on the boards and addition of the prompter on the right lend the figure additional verve.

The Techniques of Lithography

Above:
Drawing on the stone plate
Illustration

Below:
Contemporary photograph of a litho-graphic shop, photo 1894

Lithography was developed around 1796 by Alois Senefelder. The basis of the process is that a stone plate is ground flat for use in printing, the printing and non-printing parts being on a single level and not, as in letterpress or gravure printing, on different levels. The lithographic process requires a particular kind of stone, namely slate containing calcium. The special feature of this stone is its capacity to absorb water and grease in the same way and combine them. In the first stage of the process, the surface of the stone plate is ground flat, polished and deacidified. Following this, it can be painted with a greasy ink or greasy chalk. After that, the stone is etched, to make parts covered with drawings ready to absorb grease and render the undrawn stone surfaces water-absorbent and grease-repellent. After the drawing has been powdered with talcum, a solution of gum arabic and nitric acid is applied. The acid reacts with the calcareous slate and causes a slight formation of bubbles on the non-drawn surfaces. The gum + acid solution is left on the stone until it dries, as a result of which the pores of the stone close up at the undrawn places and the grease on the drawn parts makes the stone soapy. This makes the chalk and ink resistant to water. Once the etching solution is dry, it is washed off.

A special advantage of making lithographic printing plates is that various techniques can be used. For example, lines painted on by brush can be structured or highlighted by engraving. Toulouse-Lautrec also used the *crachis* (spittle) process, in which splashes

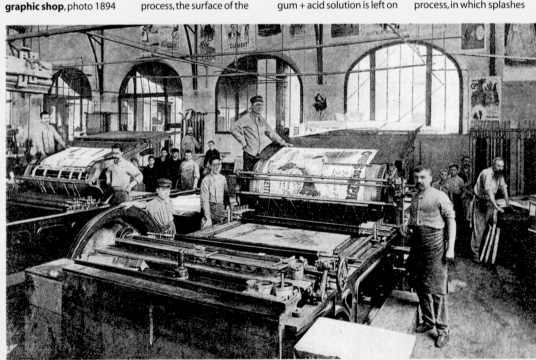

are applied to parts of the stone with a brush and metal net. The process serves to bring out shading and soft transitions between various colors.

Lithographic processes require great confidence of hand in the artist's use of the drawing medium, as correction is not possible. The advantage is that the artist's drawing hand is applied directly to the lithographic plate and thence on to the paper, without a third person having to transfer the drawing to the lithographic plate and distort the original impression, as can happen with copper engraving. After the plate has been placed in a hand press, the printing ink is rolled on to the plate with rollers. The printing process has to be repeated for each color, as not all colors can be printed at the same time. Strong pressure serves to roll the ink on to the paper, which is thereby smoothed out. The cover of *L'estampe originale* shown below (1893) depicts a lithographic press of this kind. Because of the format of lithographic plates, sometimes up to four plates are needed for large posters. On a run of 1,000, this means 4,000 operations, not including the repetitions necessary for the various colors. Even so, lithography is a very economical process, because unlike relief plates of metal or wood the stone does not wear out, and after a poster is printed it is cleaned and reused.

The cover of *L'Estampe originale* was prepared for a society that had set itself the goal of distributing modern graphic work by interesting collectors in lithography, which had hitherto been regarded as of little artistic interest. In the foreground stands the well-known dancer and friend of Toulouse-Lautrec, Jane Avril, who is looking at a fresh proof. Tradition has it that Toulouse-Lautrec showed several test proofs to his friends before deciding on the final version.

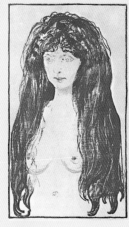

Edvard Munch
Sin, 1901
Color lithograph
69.6 cm x 39.5 cm
Vienna, Grafische
Sammlung Albertina

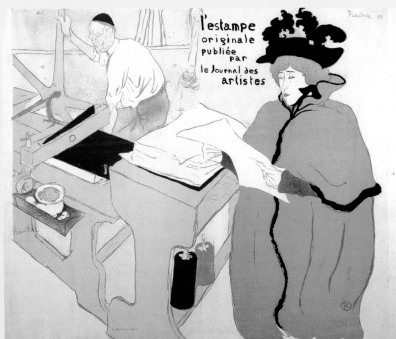

Cover of L'Estampe Originale, 1893
Lithograph in four colors
58 x 74 cm
Northampton, Smith
College Museum of Art

After the Moulin Rouge poster had made him famous overnight, Toulouse-Lautrec worked intensively on new designs and pictures. Numerous new acquaintances such as Marcelle Lender inspired him to new pictorial creations that added further peaks of artistry to his oeuvre. Toulouse-Lautrec's interest in the little-regarded media of photography and lithography marked him as an artist of the avant-garde who was not put off by traditional judgments and ways of doing things.

Outwardly, his success in 1893 manifested itself in his first one-man show at the distinguished Galerie Goupil, which his school friend Maurice Joyant organized for him. After his friend Dr. Bourges got married, Toulouse-Lautrec lived by himself for the first time. The signs that he was losing control over his life and that he was becoming an alcoholic became increasingly evident.

The Corinth Canal,
1893

Toulouse-Lautrec
ca. 1894

1892 Corruption scandal following the bankruptcy of the Panama Canal company. Numerous parliamentarians implicated. Economic crisis in the USA (until 1896). General Electric Company established, world exhibition in Chicago.

1893 Opening of the Galerie Vollard, foundation of the Independent Labour Party in England. France and Russia conclude a security pact. Rudolf Diesel granted a patent on his diesel engine. Aubrey Beardsley does his drawings for Oscar Wilde's *Salome*.

1892 Does posters for Aristide Bruant

1893 First one-man show at the Galerie Goupil. Toulouse-Lautrec leaves Jane Avril for the singer Yvette Guilbert. He lives for a while in a high-class brothel in the rue d'Amboise, where he maintains a studio of his own.

1894 Works for *La revue blanche*.

Opposite:
The box with the golden mask, 1893
Color lithography, 30.5 x 24 cm
Albi, Musée Toulouse-Lautrec

Right:
Yvette Guilbert, 1894
Thinned oil paint and charcoal on paper,
186 x 93 cm
Albi, Musée Toulouse-Lautrec

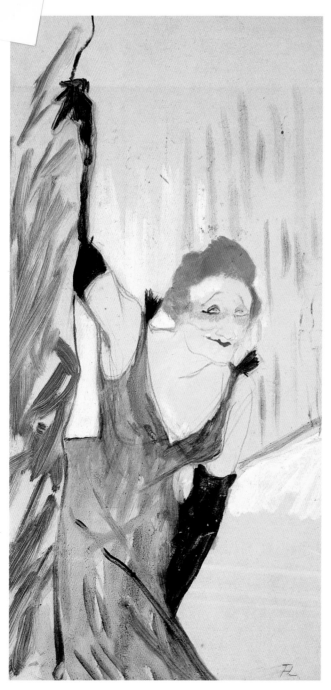

The Curtain Goes Up – the Café-Concerts

Café-concerts had been a feature of Parisian life since the 1840s. Initially their clientèle had come from the working classes and petit bourgeoisie, but by the 1870s venues like Les Ambassadeurs near the Champs Elysées were being frequented by the grande bourgeoisie. Contemporary accounts describe the atmosphere in the café-concerts as very boisterous. The public often interfered in the performances, which led to uproar. The noted dandy Nevill writes: "Hordes of young men used to go to Les Ambassadeurs to dine, and would noisily applaud all the singers, making vociferous comments on their charms."

In the first part of the performance, the (female) singers performed in evening dress, whereas in the second part a short play or ballet was offered.

Yvette Guilbert takes a bow, 1894
Reproduction on photographic paper painted over with oil
48 x 28 cm
Albi, Musée Toulouse-Lautrec

Yvette Guilbert, photo ca. 1894

Loïe Fuller, photo ca. 1892

American-born Loïe Fuller's new style dance of veils made her briefly a star.

She secured the lengths of her gowns to poles, which enabled her to achieve three-dimensional effects with her movements. Reminiscent of *art nouveau*, the fluid lines of the drapes as they are thrown up reduce the importance of the figure and highlight the garment as sculpture in motion.

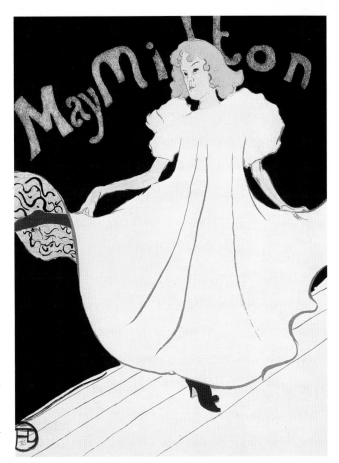

It is no surprise that, after his interest in Montmartre had waned somewhat, these venues should appeal to Toulouse-Lautrec. His endeavors to observe people and record their movements and gestures found an ideal arena in the café-concerts.

Among the best-known singers of the day was Yvette Guilbert (1867–1944), for whom Toulouse-Lautrec even did two portfolios of drawings. The oil study, in which the singer takes a gracious bow, was in the first portfolio. With just a few strokes of the brush, Toulouse-Lautrec captures the practised entrance of the star in front of an undefined background, using his customary thinned paint. The face displays slightly caricatured features, which Guilbert initially did not take kindly to, but she allowed herself to be persuaded of the artistic value of the album, because she wrote to Toulouse-Lautrec: "Dear Friend, thank you for your lovely drawings … Am satisfied! satisfied! and my whole gratitude to you is assured."

For the dancer May Milton, Toulouse-Lautrec did a poster that shows her in her typical dance pose. She usually performed in a white dress such as young girls wear at their first ball, in order to amuse the audience with the contrast of coarseness and childish innocence.

May Milton, 1895
Color lithograph (poster)
79.5 x 61 cm
Paris, private ownership

In this poster, the composition is simplified still further. The dominant blue of the background and sloping boards of the stage thrust the white figure of the dancer into prominence.

The Singer, Aristide Bruant

Among the most spectacular figures of Paris's night life was the one-time office clerk Aristide Bruant (1851–1923), who in 1885 opened a cabaret called Le Mirliton (the Reedpipe) in the Boulevard Rochouart. Bruant's rough, unconventional singing style, which included abusing the public, was considered highly provocative by his contemporaries, and assured him of years of popularity even in loftier social circles. Members of the latter flocked to his performances, to be amused by his songs about prostitutes and criminals sung in a low argot. Toulouse-Lautrec first went to the place in about 1886 and soon made Bruant's acquaintance. Bruant was enthusiastic about the unusual pictures the young count drew, and hung them up in his cabaret. Although very different in character, the sensitive and cultivated painter and the coarse Bruant got on very well for some years.

Toulouse-Lautrec did four posters for Bruant. The first and best-known was done for Bruant's performances from June 3, 1892 at the café-concerts at Les Ambassadeurs, near the Champs Elysées. It shows

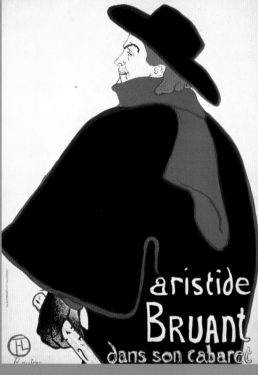

the singer in his unvarying stage costume of cloak and scarf, wearing a hat and carrying a rough stick as he enters an illuminated area – possibly the stage. His portly physique is clearly cut off by the edges of the poster, which, combined with his severe mien, lends him an almost menacing presence. Additional tension is created

Aristide Bruant dans son cabaret, 1893
Lithograph in four colors (poster)
133.5 x 96.5 cm
Philadelphia, Free Library

in the picture by the unclear import of the shadowy figure in the background. An irregular, obviously handwritten script encloses Bruant's person from above and below, thus distancing him despite the close-up image. The T-shape formed

Aristide Bruant, ca. 1890
Photo portrait by Nadar

by the red scarf might almost be considered code for the designer of the poster.

Pierre Ducarre, director of Les Ambassadeurs, was displeased by the poster. He is said to have shouted: "What a mess! It's horrible! Take it away at once!" and refused to hang it up, whereupon Bruant threatened not to perform. After a violent quarrel, it was eventually put up, and was an instant hit with the public. Bruant's performances were so well attended that the poster was reprinted for his performance at the Eldorado.

In his 1893 poster *Aristide Bruant dans son cabaret*, Henri de Toulouse-Lautrec used a twisting movement instead of the frontal figure, which changed the provocative effect of the first poster into a typical silhouette figure.

Ambassadeurs: Aristide Bruant, 1892
Lithograph in six colors (poster)
133.8 x 91.7 cm
Paris, private ownership

In the Box – the Theater Period

From 1893, Henri Toulouse-Lautrec's interest turned with renewed vigor to the theater and operetta. He himself said of it: "The plays don't matter to me. At the theater, however bad it is, I always enjoy myself." In his search for new stimuli and subject matter, he needed constant variety. His desire to observe people was well served by the theater, because the box and stalls system gives rise to special relationships of seeing and being seen such as other locations do not provide. He found subject matter in the auditorium as well as on the stage.

He drew the famous actress Sarah Bernhardt (1844–1923) as Phèdre in the eponymous play by Racine. This was the role that marked the beginning of the Sarah Bernhardt cult, and the actress rapidly became an international star. Bernhardt did not share the fate of many actresses, singers and dancers such as La Goulue, Loïe Fuller and Jane Avril, who blazed forth briefly and were as quickly forgotten, later dying in poverty. Henri de Toulouse-Lautrec chose the scene in which Phèdre confesses to her nurse her love for her stepson, and he strove to give direct expression to the drama of this key scene. Presumably, in order to be able to study the faces closely, he had taken a box close to the stage.

The painter is likewise close to the scene in the *Bolero* painting, which shows the new star of the Paris

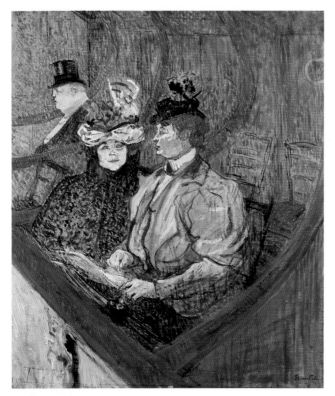

The large box, 1897
Oil and gouache on card
55.5 x 47.5 cm
London, private ownership

Sarah Bernhardt in Phèdre, 1893
Lithograph
35.5 x 23.5 cm
Washington, National Gallery of Art (Rosenwald Collection)

The intensity of movement and emotion is reinforced by the contrast in the depiction of the human figures.

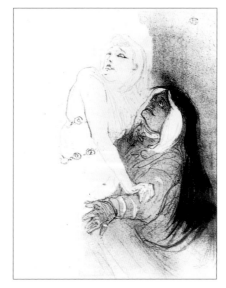

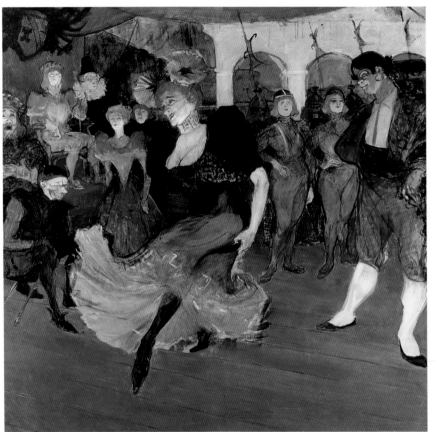

Marcelle Lender dances the bolero in the operetta *Chilpéric*, 1896
Oil on canvas
145 x 150 cm
New York, private ownership (Mrs John Hay Whitney)

Marcelle Lender approaches the front edge of the stage with a light, floating step. The people standing expectantly around her, who represent courtiers of the Merovingian king Chilperic, form a static contrast to her dance.

Of special interest in this picture is the way the dancer is not isolated as a silhouette, as in other pictures by Toulouse-Lautrec, but is brought out by contrasting color and her body language.

Another novelty of the picture is the use of shimmering pink, green, and blue tones to reproduce the atmosphere of the theater. The lighting effects of gas light are an additional demonstration of Toulouse-Lautrec's great technical skill.

Operetta, Marcelle Lender (1863–1927) in her first great hit, *Chilpéric*. Toulouse-Lautrec was so fascinated by her beauty, the elegance of her movements and her personality that he went to see the operetta 20 times and made countless studies of it. His comment thereupon was: "I only go to see Lender's back."

Two months later the picture was finished. In his depiction of Marcelle Lender, he largely dispensed with the caricature elements in characterization such as he had deployed to highlight the ordinariness of the stars from Montmartre. Marcelle Lender had already been painted by Toulouse-Lautrec in 1895, in a portrait lithograph in which his admiration is clearly evident (see page 58).

The Studio

After Toulouse-Lautrec moved out of his mother's house, where he had his own studio, he changed his home and studio frequently, a period that is only partly documented. However, his stay at the summer house studio at the corner of Boulevard de Clichy and rue de Caulaincourt, made available to him and his friends Henri Rachou and René Grenier by Père Forest, certainly left its mark on his work. From 1885, he began to paint portraits in the garden (page 30), his main interest being in depicting people, i.e. not in painting in the open air like the Impressionists.

When he and his friend Dr. Bourges moved into an apartment at 19, rue Fontaine, he rented a studio at 7, rue Tourlaque. He kept the studio on when Dr. Bourges got married in 1893 and a greatly disappointed Toulouse-Lautrec had to look for an apartment of his own. Maurice Joyant has left us a description of his friend's studio:"… very spacious, with a small staircase that led to a balcony and a small room. A ladder rose to the ceiling so he could paint

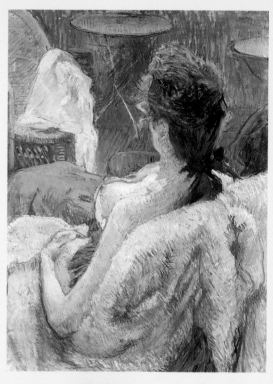

Model resting in the studio, 1896
Tempera and oil on card
65.5 x 49.2 cm
Los Angeles, J Paul Getty Museum

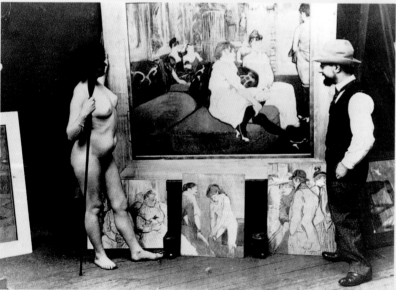

large canvases; high up on the studio wall were the large-format parody of Puvis de Chavannes's *Sacred Grove* and circus scenes with clowns thrice life-size, while on the floor was an incredible accumulation of canvases, cartoons and tracings … a zinc wine-shop table, cane chairs, divans with cushions, a number of extraordinary *objets d'art*, Japanese kakemonos and netsuke, finally pink or white ballet shoes, female head-dresses, pink dominos,

Lautrec and a nude model in front of his painting *In the drawing room in the rue des Moulins*, photo ca. 1894

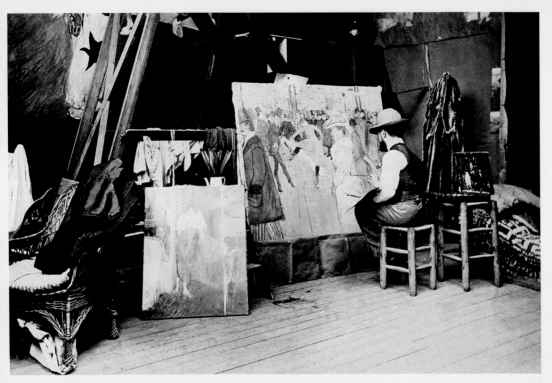

women's corsetry and – arranged on the rungs of the ladder – white clowns' hats. The space in the middle, where Lautrec had his easels and paintings, was very restricted. Like many artists who paint from models and do not want them disturbed, he was irritable when at work, even with close friends. He was equally obstinate when it came to where things should be: the cleaning woman was absolutely forbidden to clean up or touch anything. A housecoat or other article he left around for painting had to stay where it was. Dust gathered everywhere, too."

The jumble of equipment, junk, exotic *objets d'art* and series of photos also astonished other visitors to the studio. Unlike Edgar Degas, who had a rather spartan studio to which hardly anyone was admitted, Toulouse-Lautrec loved accumulating odd and ill-assorted objects, all of which had a special meaning quite irrespective of their material value. The writer Paul Leclercq says of the studio at 15, Avenue Frochot: "It was a bright, extensive room, crammed with easels, untidy tables, canvases, chairs, a rowing machine and finally a large armchair, in which he sat me

when he painted my portrait (page 74). A narrow internal staircase, very steep, led up along a wall, linking the studio with two small rooms, the first of which served as a bedroom, the second as a changing room. The furniture was simple." Towards the end of his life, Toulouse-Lautrec increasingly dispensed with creature comforts in order to devote himself entirely to his art. He said of his last studio in the Avenue Frochot, where he also lived, "I hope to end my days in peace here."

Toulouse-Lautrec in the studio, working on the painting *Au Moulin Rouge - La danse* (page 29), photo ca. 1890

Photography – Mirror of Reality

Like many of his contemporaries in the art world, Toulouse-Lautrec took up photography, which had completely changed the understanding of both representation and reality. On the one hand, painters were initially afraid that the new technology would make them redundant, while on the other they were excited by the manifold opportunities it offered. Photography could replace laborious drawing studies, which served mainly as starting points for a painting. Using a photo, the subject could be changed in form and size when translated into a painting, and thereby distanced. Changes to the photograph, for example in the section taken, could lead to a new interpretation of the subject matter in the painting. Important in

Portrait of Mademoiselle Marcelle Lender (bust), 1895
Color lithography
32.9 x 24.4 cm
London, Victoria and Albert Museum

Marcelle Lender, photo ca. 1888

Monsieur Toulouse paints Monsieur Lautrec-Monfa, photo montage ca. 1890 by Maurice Guibert

the creation of a painting is the role of color, which was not reproduced in the photo and therefore had to be recalled from memory or the imagination. As Toulouse-Lautrec's painting style was not directly orientated to reality either in structure or coloration, photographs could only serve as something to work from.

The photographer Paul Sescau, who was a friend of Toulouse-Lautrec (see pages 40–41) and for whose studio he did an advertising poster in 1896, took photos at the artist's instructions that would serve as stimuli during painting. Paul Sescau was also the first to photograph the works of the painter, who, probably troubled by forebodings of death, was concerned to have his work documented during his lifetime. Toulouse-Lautrec took advantage of photography's scope for reproducibility and photo-montage, for amusing ends. As the triple portrait made by the amateur

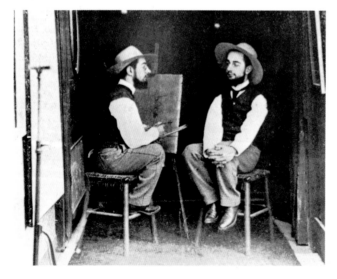

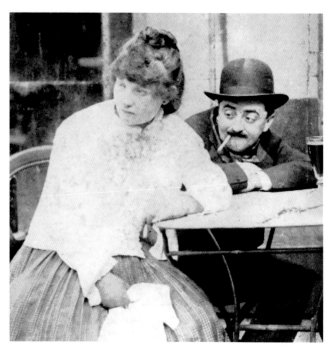

The painter and friend of Toulouse-Lautrec Maurice Guibert, with a model, photo by Paul Sescau, 1891

Toulouse-Lautrec's friend, the champagne dealer Maurice Guibert, is seen in this photo by Paul Sescau with a so far unidentified model. The photo is rather conventional, but retains a certain tension due to the fact that the subjects are gazing with interest at an unknown object.

A la mie (After the meal), 1891
Water color and gouache on paper
53 x 67.8 cm
Boston, Museum of Fine Arts (S. A. Denis Collection)

In transposing a photo by his friend Paul Sescau, Toulouse-Lautrec creates a totally different scenario: satiety, boredom and alcoholism are the subjects of this sobering picture that captures the depressing atmosphere of a hangover pick-me-up.

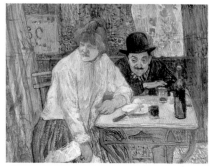

photographer and friend Maurice Guibert (1856–1913) indicates, he was interested in *jeux d'esprit* involving his own individuality. As he studies his counterpart, which is indeed Lautrec himself, not his mirror image, he draws his own facial features on the canvas propped on the easel in front of him.

His close cooperation with photographers was unusual for the period, because photography was not yet acknowledged as art, and accordingly had little status. Though other artists such as Edgar Degas had already used photography as an aid prior to Toulouse-Lautrec, the triple portrait confirms that the latter had recognized the manifold artistic opportunities of the medium and was ready to experiment with them.

An example of Henri de Toulouse-Lautrec's translation of photography into painting is *A la mie (After the meal)*, a picture from 1891. The starting point was a photo showing Maurice Guibert (see pages 40–41) and an unknown model. Toulouse-Lautrec re-used the position of the figures in slightly modified form. Decisively changed, however, are the faces: Guibert and the model have become a drunken elderly couple quaffing a glass of wine after a meal.

In the Belle Époque 1894–1895

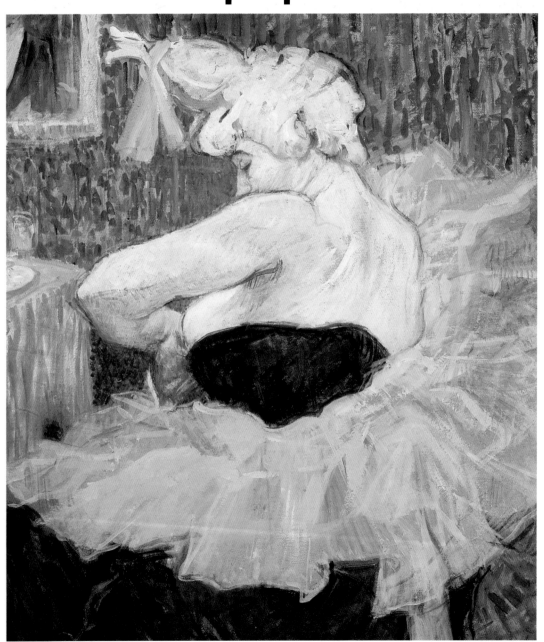

Although his health was in steep decline from syphilis and alcohol abuse, Toulouse-Lautrec worked with great energy at his pictures, graphic work and illustrations for books and periodicals. The brothel series tapped a new field of subject matter; but a major part of it remained concealed from the public until after his death. The *Elles* portfolio, which likewise deals with the subject, was a financial failure.

In contrast, his honing of his lithographic technique confirmed his reputation as Paris's most up-to-date poster artist. His travels brought him into contact with numerous other artists, including James McNeill Whistler. Toulouse-Lautrec's passion for Japanese art became more and more obvious, taking the form of a marked passion for collecting.

The Lumière brothers Auguste and Louis

Toulouse-Lautre ca. 1889

1894 Bombay lawyer Gandhi organizes the Indian population in South Africa with his tactic of non-violent resistance. Beginning of the Dreyfus affair, which ends with Captain Alfred Dreyfus being found guilty. Gustave Caillebotte bequeaths his collection of Impressionist art to the Musée de Luxembourg - the state turns some of the pictures down. World exhibition in Antwerp. Founding of the League of German Women's Associations, demanding equal rights for women.

1895 First public film performance with the 'kinematograph' by the Lumière brothers Auguste and Louis. Discovery of X-rays.

1894 Toulouse-Lautrec travels to Holland, Belgium and England on the occasion of his own exhibitions. In London, he meets Oscar Wilde and James McNeill Whistler. Later in the year he makes the acquaintance of *art nouveau* artists Henry van de Velde and Victor Horta. The Galerie Durand-Ruel organizes an exhibition of the artist's latest works, mainly lithographs. In the same year a portfolio of lithographs appears, dedicated to the singer Yvette Guilbert. In the vacation he embarks on a sailing trip to Spain.

Opposite:
The female clown Cha-U-Kao at the Moulin Rouge, 1895
Oil on card, 54 x 49 cm
Paris, Musée d'Orsay

Right:
Self portrait, 1896
Lithograph, 10 x 9 cm
Albi, Musée Toulouse-Lautrec

At the Moulin Rouge: Mr Warner, 1892
Oil on paper
57.3 x 45.3 cm
Albi, Musée Toulouse-Lautrec

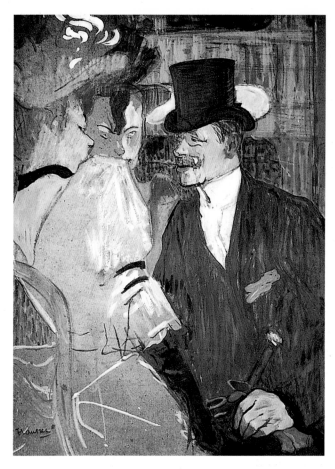

Illustrator of the Night

The Englishman at the Moulin Rouge: Mr. Warner, 1892
Oil and gouache on card
85.7 x 66 cm
New York, Metropolitan Museum of Art

Despite his declining interest in Montmartre, Toulouse-Lautrec continued to paint scenes of the Moulin Rouge. The sections he took were now small, allowing him a more precise study of faces. He was no longer interested exclusively in dancers and singers, but also in the often foreign, overwhelmingly male guests at night clubs, who sought diversions of the most varied kind in the informal atmosphere. The artist studied their faces at length: they betrayed covetousness, amusement and bloated satisfaction with what they had seen.

From places such as the *promenoir* in the Moulin Rouge, it was possible to watch unobtrusively the lightly clad dancers on the dance floor as well as the other visitors sitting at the tables. The desire to see and be seen, the mixture of demimonde, bourgeoisie, and nobility, and the spectacular dance offerings, which disregarded the accepted morals of the time, were what constituted the great charm of nights spent in the music hall and cabarets. Around this time, the first nude dances were documented, taking place despite being strictly forbidden, and enjoying great popularity. Once the ban was relaxed in the 20th century, night life changed at the foot of Montmartre: but the district around the Place Pigalle is still known for its erotic delights.

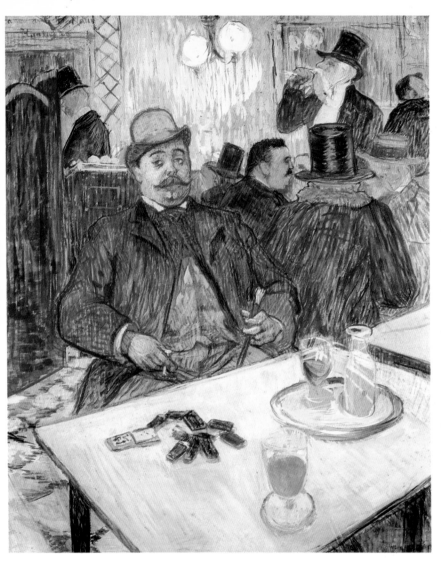

Portrait of Monsieur Boileau, 1893
Oil on canvas
80 x 65 cm
Cleveland, The Cleveland Museum of Art (Hinman B. Hurlbut Collection)

In Monsieur Boileau, Toulouse-Lautrec has caught a typical night-owl of the period. The obese, well-dressed man sits in a bar smoking a cigarette while looking round at other customers. The pronounced top view of the table indicates that the viewer is in a standing position. It is left up to the viewer to imagine whom the glass of green absinthe on the nearer side of the table belongs to. Absinthe was a popular drink with all classes of society at the time, now banned in France and other European countries for causing brain damage.

... a thing is never beautiful only because it is new ..., novelty is rarely the essence. Only one thing is always involved: making something better from its essence.

Henri de Toulouse-Lautrec

Elles –a Homage

Visiting brothels was a regular part of Toulouse-Lautrec's life. In them, he found an ideal location to satisfy his eternal wish to observe people – as a regular at the establishment, he could spend weeks at a time there studying and recording the life of the women in it. He was thus able to reproduce the everyday life of prostitutes in numerous drawings. He was mainly interested in how the women spent the time waiting for their clients: "Professional models always seem stuffed; the women there are alive ... I would not dare to give them 100 sous for posing, and God knows, they are worth that much. They loll about on the couches like animals ... They are quite without pretensions."

The apparent unaffectedness of the prostitutes and physical attitudes

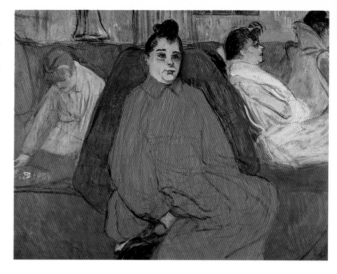

The divan, 1893
Oil on card
60 x 80 cm
São Paulo, Museu de
Arte Assis
Châteaubriand

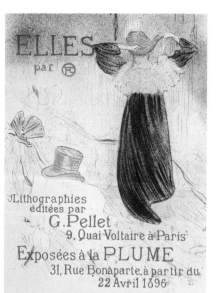

Title page of *Elles*,
1896
Color lithograph
57.5 x 46.8 cm, private
ownership

The title page shows what appears at first glance to be a *bourgeoise* at her toilette, but the top hat betrays the presence of a man. Men in street clothes in a woman's dressing room were not customary, so that one may assume that prostitution is the subject matter.

quite outside bourgeois norms could not help but captivate an artist like Toulouse-Lautrec, who was interested above all in the human figure. In order to be able to work less disturbed, the artist spent several months of 1893 living at the brothel in rue d'Amboise, where he had a studio of his own and took in meals. Because of his friendly and generous manner, he was welcome in the brothels, and won the trust of the prostitutes and their proprietors.

Toulouse-Lautrec's interest in the life of these women finally culminated in the creation of the series of graphics called *Elles*, which records the everyday life of prostitutes. The series was intended as homage (*hommage*) to women in general and prostitutes as social outcasts in particular. Toulouse-Lautrec provides descriptions devoid of all social criticism or sentimentality, successfully depicting his subjects with great

In the drawing room in the rue des Moulins, 1894
Oil on canvas
110 x 120 cm
Albi, Musée Toulouse-Lautrec

The painting shows the reception room of one of the brothels Henri de Toulouse-Lautrec frequently visited. The prostitutes sit around in bored silence, waiting for clients. In the artificial light, resignation and lethargy register twice as sobering. By the use of warm and intense tones for the interior, the artist underlines the contrast between splendor and wretchedness, which generates the particular tension of the picture.

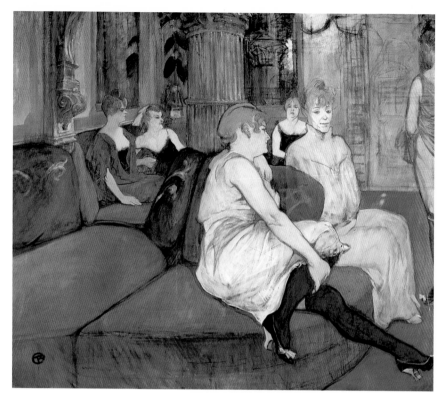

humanity and understanding for the predicament of prostitutes.

As the paintings with the brothel scenes were never publicly shown during the artist's lifetime, the lithographs of the *Elles* series were the only works on the subject that Henri de Toulouse-Lautrec made available to the public.

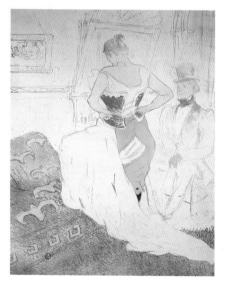

Woman in corset – a fleeting conquest, 1896
Chalk on lithograph
52.4 x 40.5 cm,
London, private ownership

Though similar in subject matter to the title page, the scene is more explicit. A man in street clothes watches a prostitute getting dressed or undressed. The small picture behind, showing a lascivious satyr with a naked nymph, provides a silent commentary.

Muse and Star: Jane Avril

Jane Avril first trod the boards with her wild dances in 1893 at the Jardin de Paris, a newly opened café-concert. The daughter of a demi-mondaine and an Italian nobleman, her public debut had been as a trick rider. Later, during a nervous breakdown, she was apparently encouraged by her lover, a medical student, to exercise her turbulent temperament in dance. At her wish, Toulouse-Lautrec was commissioned to design a poster. To do justice to her popular name "La Mélinite" (a form of high explosive!), the artist tried a completely different form of poster design. Within a frame in a linear style anticipating *art nouveau* (then on its way in), he shows part of the stage with the dancer in a can-can pose, considered shocking at the time. In the can-can, the dancers kicked their legs in the air so that the public could see their underskirts. At that time, even showing a female calf in public was considered indecent . Avril raises her leg in a rotating display as if wanting to

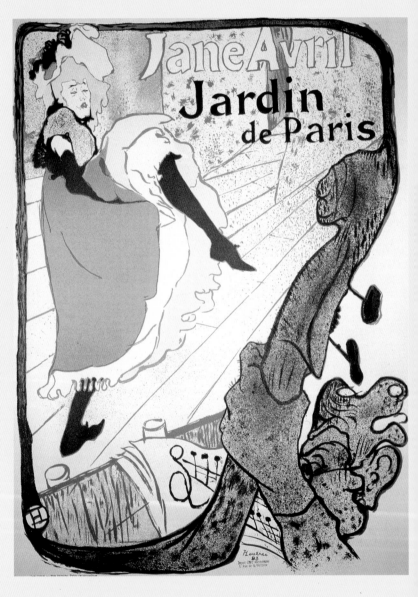

Jardin de Paris: Jane Avril, 1893
Lithograph in four colors (poster)
54 x 40 cm
Private ownership

My God, has he got brass, this Lautrec! No girlishness about him, either in his drawing or his colors.

Felix Fénéon (Journalist and Anarchist)

Jane Avril, photo ca. 1890

elements produced by the *crachis* technique in the lithography makes the poster appear to vibrate, making the representation an echo of the dynamics of the dance.

Toulouse-Lautrec had already used the figure of Jane Avril in his poster for *Le divan japonais*, a café-concert opened in 1893, where her silhouette appears in the foreground. She sits in a box with the art and music critic Edouard Dujardin (pages 40–41) during a performance by Yvette Guilbert, who was her successor in Toulouse-Lautrec's favor. In his radical sectioning approach, Toulouse-Lautrec has simply sliced off Yvette Guilbert's head with the edge of the picture. Clearly her characteristic figure in combination with the black gloves and light dress provided adequate identification. Neither Jane Avril nor her companion seem to be following the performance. He is much more interested in the charms of his neighbor, she in smiling coquettishly. Even in 1933, forgotten and impoverished, Jane Avril was to say of Toulouse-Lautrec:

dance out of the picture. Although Toulouse-Lautrec shows her entire figure, we nonetheless get an impression of a section. The breach of the frame is effected in this case by the figure of the bassist who, reduced to a mask, consults her music. Toulouse-Lautrec concentrates in the figure of the dancer three of the four colors used in the picture, only the covered green serving to articulate the rest of the picture. The radical way that color, motion and perspective are used is rare even for the oeuvre of Toulouse-Lautrec. It is also obvious that he has come a long way technically. The juxtaposition of monochrome surfaces and grainy character of the

"Undoubtedly I owe to him my fame, which I enjoyed from the time his first poster of me appeared."

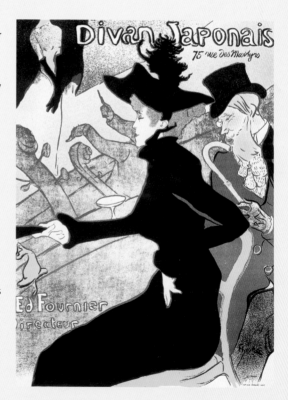

Divan Japonais, 1892–1893
Lithograph in four colors (poster)
80 x 60 cm
Paris, private ownership

Kitagawa Utamaro
Half-length portrait of a woman holding a teacup, from the *Meisho Koshikake Hakkei* **series**, 1913
Color woodcut
38 x 28 cm
Cambridge,
Fitzwilliam Museum

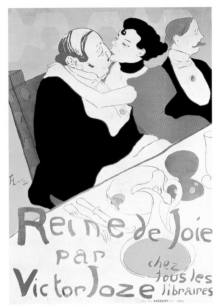

Reine de Joie, 1892
Lithograph in four colors (poster)
149.5 x 99 cm
Private ownership

A young woman cuddles up to a portly older man sitting beside her at the banqueting table. Lautrec's line blends the two silhouettes into one. A comparison with a woodcut by Utamaro shows the same dominance of line, in the Japanese manner. Intense colored surfaces are also an important element of design in Toulouse-Lautrec. However, unlike the Japanese woodcut, the lithograph reproduces Toulouse-Lautrec's brushstrokes, lending the poster a greater spontaneity of expression. The book advertised by the poster provoked a scandal, as Rothschild the banker considered his reputation sullied by the main character of the book. He attempted in vain to have the sale of the book banned by the court.

In the Style of the Time

Toulouse-Lautrec in a kimono, photo by Maurice Guibert, 1892

Various trends in taste influenced artistic developments at the end of the century. One major event was the journey to Japan by Théodore Duret in 1875, who brought back with him to Paris a large number of art objects. Objects of this sort had, of course, been seen in Europe previously, but it was only with the Meiji reform of 1868 that Japan had become accessible to traveling Europeans. Toulouse-Lautrec was an enthusiastic collector of Japanese art and also possessed woodcuts by the artists Koryusai and Hokusai, who dominated the style of colored woodcuts in Japan and brought the art to a previously unattained perfec-

tion. Toulouse-Lautrec had also acquired from the historian and writer Edmond de Goncourt an album of erotic scenes by the Japanese artist Utamaro, which was always in his studio as a source of inspiration. The style of these woodcuts, known as *japonisme*, presented European artists with a completely new approach to representation, that placed emphasis less on spatial depth and compositional balance than on two-dimensionality and asymmetry. The figures blend with the background, and are thereby divided into patches of color. Three-dimensionality is achieved only by the patches overlapping.

Besides Toulouse-Lautrec, others such as Edgar Degas and Vincent van

Gogh were also influenced by the compositional principles of Japanese woodcuts. This development was not restricted to France, because numerous artists in Britain were also influenced by Japanese graphics. They included James McNeill Whistler, whom Toulouse-Lautrec had got to know in London in 1894, and the brilliant draftsman Aubrey Beardsley, who was fascinated by the contrast between fine lines and intensely colored surfaces. Toulouse-Lautrec adopted the two-dimensional pictorial structure of Japanese art, the shadowlessness and, above all, the unusual pictorial sections adopted by the Japanese, and these he combined with his own individual style.

Despite sharing with it stylistic features such as a sweeping linearity, Toulouse-Lautrec was rather cautious in his attitude towards *art nouveau*. The Belgian *art nouveau* artist Henry van de Velde had invited him to his newly completed house at Bloemenwerf near Brussels, but Toulouse-Lautrec did not take to the perfectly matched colors and tasteful bourgeois atmosphere of the house. He said later to Maurice Joyant that "the house conveyed to one a yearning for Menelik's tent with lion skins and ostrich feathers, naked women – whether colored or not – with gold and red, giraffes and elephants." The house of Victor Horta in Brussels downright shocked him. Clearly, Toulouse-Lautrec was too much a child of his time to be able to value all the modern creations of his contemporaries.

May Belfort, 1895
Lithograph in four colors (poster)
79.5 x 61 cm
Paris, private ownership

The design of this poster shows clear parallels with Aubrey Vincent Beardsley, especially in the shallow pictorial depth, asymmetry and division of surfaces. The singer is holding a cat, an allusion to her well-known song *I['ve] got a little cat, / [And] I'm very fond of that.*

Aubrey Vincent Beardsley
Isolde, 1899
Color lithograph
17.8 x 12.6 cm
Private ownership

The fine draftsmanship and elegant line of Aubrey Vincent Beardsley (1872–1898) was a sensation not only in England. The typical Japanese surface elements are additionally reinforced in this drawing by an allusion to the Japanese flag – white with a red sun – while the height of the horizon generates spatial depth.

Road With No End

The years 1895–1899 were completely dominated by the numerous exhibitions in which Toulouse-Lautrec took part and which made him famous abroad. The large one-man show at Goupil's in London, in May 1898, comprised 78 works and thus represented a high point in Toulouse-Lautrec's artistic career. The exhibition was not commercially successful, but the visit to the gallery by the Prince of Wales marked the beginning of an official appreciation of his art.

Gradually Toulouse-Lautrec's creativity was impaired by his dissipated lifestyle. Conflicts with friends and relatives loomed, as from autumn 1898 he began to develop paranoia which alienated him from his environment. The unpredictability of his behavior had turned the entertaining socializer into a problem.

Marie Curie, 1894

Toulouse-Lautrec ca. 1899

1895 France conquers Madagascar.

1896 Premiere of Puccini's *La Bohème*. The first Olympic Games of modern times take place in Athens.

1897 First Secession exhibition in Vienna. Germany demands its "place in the sun" in the colonial jostlings of the great powers.

1898 The Curies discover radioactivity. Zola writes *J'accuse*, involving himself in the Dreyfus Affair.

1895 Toulouse-Lautrec makes the acquaintance of Paul Leclercq and the Natansons. In October, he takes part in the Salon des Cent poster exhibition.

1898 The largest one-man show in Lautrec's lifetime takes place in May at the London branch of Galerie Goupil.

1899 Treatment in sanatorium in Neuilly.

Opposite:
Seated woman, 1897
Oil on card, 63 x 48 cm
Munich, Bayerische
Staatsgemäldesammlung, Neue
Pinakothek

Right:
Self-portrait, 1885
Lithograph, 33 x 22 cm
Albi, Musée Toulouse-Lautrec

Strange Worlds

Were it not for his disability Toulouse-Lautrec would, he said, have preferred to be a surgeon or sportsman. His fascination for power and movement thus made him an enthusiastic spectator at sports events. It was less important what sport was involved, though cycling particularly interested him. Thanks to his friendship with the race organizer Tristan Bernard, Toulouse-Lautrec had free access to all parts of the cycling track.

The writer and editor of the periodical *La revue blanche*, Paul Leclercq, reports: "He spent the mornings there, tripping back and forth, sometimes in the middle of the track, sometimes in the cyclists' cubicles. His diminutive figure crossed giant athletes, in whom he admired the

La Chaîne Simpson, 1896
Lithograph in four colors (poster)
86 x 119.4 cm
San Diego, Museum of Art

The Driver, 1898
Lithograph
37.3 x 26.8 cm
Paris, Bibliothèque Nationale

The unusual feature of this picture is the extreme close-up of the driver who, because of his goggles, is hardly recognizable as Toulouse-Lautrec's cousin Gabriel. The viewer is positioned as though on the bonnet of the vehicle, which is clearly moving, as the cloud of smoke on the upper edge of the picture indicates.

power or bestial head. The smallest detail of their clothing amused him." In 1896, Toulouse-Lautrec went so far as to do an advertising poster for the cycle firm Simpson, showing the celebrated racing cyclist Constant Huret in training. In his studio, Toulouse-Lautrec had a rowing machine on which he exercised with great perseverance. The only other sport open to him was swimming, which he excelled at and reveled in on his travels. Swimming was the only way he could escape his disability for a while.

In his horse-racing pictures, once again Edgar Degas was an important influence, even though in his youth Toulouse-Lautrec himself had made numerous studies of riders and hunting parties. Degas had enriched the repertory of city life scenes with a series of pictures at the race track, thereby becoming chronicler of the elegant social events on the race track at Longchamps near Paris. Vying with the famous Degas was

fraught with difficulty, but Henri de Toulouse-Lautrec did not shrink from the attempt – and in his drawings and studies he opened up a new perception of what happens on the race track. The public, which in Degas's pictures is always visible, if only on the edge of the pictures, is in Toulouse-Lautrec no longer involved at all. Unlike in the theater and cabaret, in sport only the participants interested him.

Toulouse-Lautrec's interest in sport even embraced car racing, which many of his contemporaries still found unsporting and loud. His cousin Gabriel Tapié de Céleyran was one of the first people in Paris to own a motor car, which enabled Toulouse-Lautrec to depict him at the wheel. The particular charm of the subject, which has a touch of adventure to it, lies in the contrast between Gabriel wrapped in fur and recognizable only from his nose, and the fine silhouette in the background, showing a lady walking a dog that clearly does not care one bit for the noise of the machine. In this case, the sectional nature of the scene depicted highlights the speed of the car, whose invention and popularization around the turn of the century confronted people with a new way of life.

The jockey, 1899
Color lithograph
(proof)
51.5 x 36 cm
London, private
ownership

In a complete break with the customary representation, the two jockeys are shown at full gallop in a slight bottom view from behind. This creates the impression that the viewer is likewise seated on a racehorse and is therefore also a jockey. Even though there are individual pictures by Degas showing scenes from racing, the extreme close-up in connection with the back view of the jockeys is Toulouse-Lautrec's own innovation. The publisher Pierrefort had planned to publish four lithographs on the subject of racing, but only this one from a water color was produced. As the artist had been unable to ride since childhood, the immediacy of the scene is all the more astonishing.

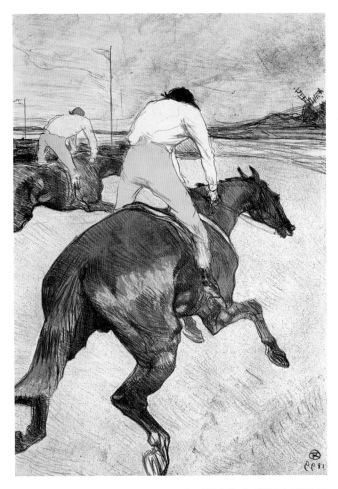

Companions

Portraits of his friends and relatives – together with scenes from the night life of Paris – constitute a central feature of Toulouse-Lautrec's oeuvre.

His friend Paul Leclercq gives an account of a portrait sitting in his studio: "As soon as I entered, he told me to take up the agreed pose in a broad wickerwork chair, and he placed himself in front of his easel with the small felt hat he always wore in his studio. Then he turned his pince-nez on me, screwed up his eyes, took up his brush and made … a few strokes with very thinned paint. While he was painting, he did not utter a word, but seemed to be

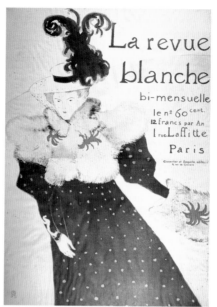

La revue blanche, 1895
Lithograph in four colors
130 x 95 cm
Albi, Musée Toulouse-Lautrec

The model for the poster for *La revue blanche* was Misia, the wife of the periodical's publisher, Thadée Natanson. She was a well-known beauty and was much admired by Toulouse-Lautrec for her looks and her independence of mind. She often visited him in his studio.

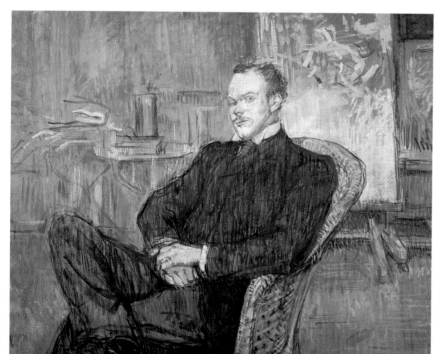

Portrait of Paul Leclercq, 1897
Oil on canvas
54 x 64 cm
Paris, Musée d'Orsay

The founder and later editor-in-chief of the periodical *La revue blanche* is depicted by Toulouse-Lautrec in a, for him, rather rare landscape format showing the studio in the background. The intensely observant facial expression is contrasted with the casual sitting position. In the background are several incomplete paintings, including a dance study placed on an easel behind Leclercq.

devouring something very tasty behind his moist lips."

Still more impressive is the portrait of Toulouse-Lautrec's cousin Gabriel, a witness to the deep friendship that he felt for his tireless companion. Even though Toulouse-Lautrec often swore at him and showed him up in front of others, the long-suffering and reticent man remained his closest friend. Paul Leclercq describes Gabriel at his first encounter with him as "a thin, very serious, odd, elderly-looking gentleman. I had often ... seen his figure in the weirdest costumes and attitudes in posters and engravings by Toulouse-Lautrec." Already visible at Toulouse-Lautrec's side in the *promenoir* picture (pages 40–41), Gabriel's larger physique and wholly different temperament made a strange contrast with his diminutive cousin. Despite all their differences and the provocation by Toulouse-Lautrec, Gabriel would never leave him in the lurch.

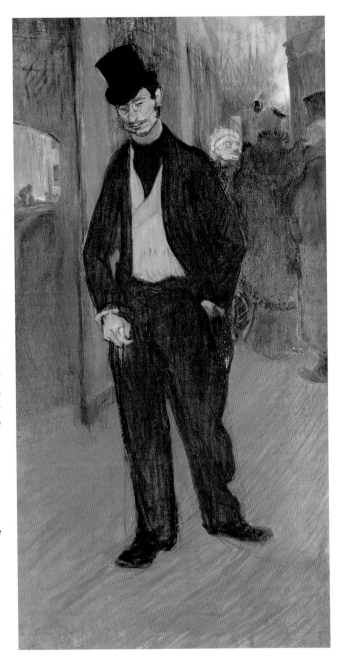

Gabriel Tapié de Céleyran in the theater foyer, 1894
Oil on canvas
110 x 56 cm
Albi, Musée Toulouse-Lautrec

Toulouse-Lautrec's cousin Gabriel Tapié de Céleyran shuffles with his typical stoop along a corridor at the Comédie Française, where he and his cousin often went to see classical plays.

A Poster is Born

How chance events could trigger off the creation of a work is shown by the genesis of the poster for the international poster exhibition, the Salon des Cent in Paris. Toulouse-Lautrec usually spent his vacations on the Atlantic coast in the south of France, subsequently going on to his mother's at the Château de Malromé near Bordeaux. To get there, he traveled by rail from Paris to Le Havre, where he boarded a boat in the direction of Bordeaux. In 1895, on board the ship *Le Chili*, he fell in love with a passenger from Cabin 54, who was traveling unaccompanied to her husband in Dakar in Senegal. Toulouse-Lautrec was so captivated by her that he did not leave the vessel in Bordeaux as originally planned but wanted to go on to Dakar with her. By Lisbon, his companion Maurice Guibert (pp. 40–41, 58–59) finally succeeded in bringing home to him the impertinence of his behavior and induced him to leave the ship.

From a photo taken of her on board and a drawing, he produced a lithograph which he continued to amend several times until it met his standards of perfection. The third version was finally translated into a poster advertising an international poster exhibition, which opened in October 1895 at the premises of the avant-garde periodical founded by writer Léon Deschamps called *La Plume*.

A graphically lavish edition of the October 1895 issue offered a limited edition of 20 unsigned copies of the second condition of the poster [i.e. lithograph] as a collector's item. This sort of practice indicates that collectors of graphics were beginning to take an interest in Toulouse-Lautrec's lithographs. The result of this is one of the artist's most astonishing compositions, bringing together all of his previous experience with lithography and combining it with an unusually harmonious use of color. The richness of the colors already heralds the late style of the artist, in which he moved away from garish color contrasts in order to lend his works a more well-rounded character. Particularly lavish was the use of six instead of four colors, which involved two

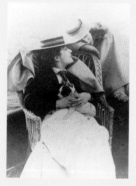

The passenger from Cabin 54, photo 1895

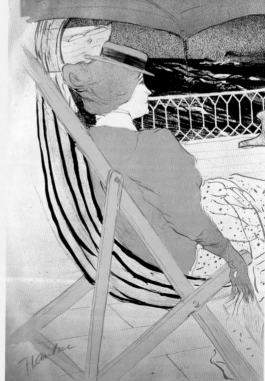

The passenger from Cabin 54 - on the yacht, 1895
Lithograph in six colors
59 x 39.7 cm
Dresden, Staatliches Kupferstichkabinett

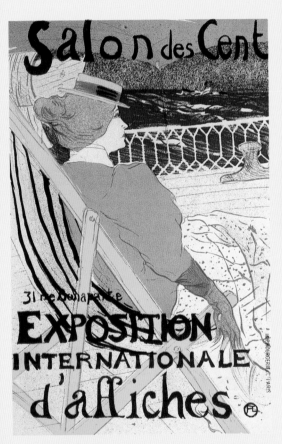

**The passenger from
Cabin 54 – on the yacht**, 1895
Color lithograph (poster)
59 x 39.7 cm
Paris, private ownership

additional runs during
printing.
The special charm of the
composition consists in the
contrast between the

movement of the ship on the
horizon and the alignment
of the woman in the deck
chair. Her position in the
picture is thus anchored by
the diagonal slat of the
deckchair, which further
stresses the relaxed seated
posture. Without showing
explicit movement,
Toulouse-Lautrec manages

to create a sense of both rest
and motion.

**Contemporary photo of
lithographic printers
Camis in Paris**, 1894

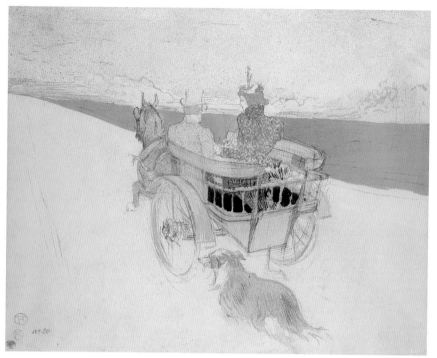

An excursion in the carriage, 1897
Lithograph
overpainted with
water color
38 x 50 cm
London, private
ownership

The couple sitting in
the cart could be the
Natansons, at whose
country house in
Villeneuve-sur-Yonne
Toulouse-Lautrec
spent the summer of
1897. The print was
done for the second
of two *Album
d'Estampes de la
Galerie Vollard*
published by the art
dealer Ambroise
Vollard in a limited
edition of 100 in
December 1897 at a
price of 150 francs.
Other artists to
contribute to these
collector editions
included Paul
Cézanne, Auguste
Renoir and Edvard
Munch.

Traveling

Traveling was a particular passion of
Toulouse-Lautrec's. In the summer
months he left the stuffiness of Paris
and boarded a ship from Le Havre to
Bordeaux, both to get some sea air
and to visit his mother in Château de
Malromé. Toulouse-Lautrec always
had a friend with him as a companion,
though he chose the itinerary.

He likewise often traveled abroad.
We know of several trips to Britain,
Spain, Belgium and Holland.
Exhibitions were usually the oc-
casion for these, like for example the
Group of 20 in Brussels, where his
pictures were on show and he could
keep in touch with developments in

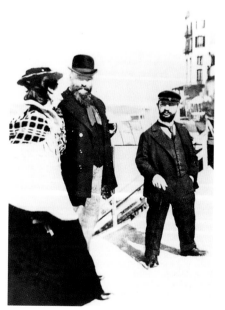

**Toulouse-Lautrec
and the Natansons**,
photo ca. 1896

The photo shows
Toulouse-Lautrec
with Misia and
Thadée Natanson in
the resort of Etretat.
The artist designed a
poster for the
Natansons' periodical
La revue blanche for
which Misia Natanson
acted as model (see
page 74).

the art world. At a celebratory banquet of the Group in 1890, the Belgian painter de Groux made disparaging remarks about Vincent van Gogh, whereupon Toulouse-Lautrec immediately challenged him to a duel. The Pointilliste painter accompanying him, Paul Signac, declared that if Toulouse-Lautrec were killed, he would carry on the fight in his place.

Unlike contemporary art, artefacts from earlier periods that he saw on his travels awoke little interest in Toulouse-Lautrec. Maurice Joyant tells of his highly idiosyncratic approach to sightseeing: "The fact was, he hated looking at things when traveling. He would do nothing contrary to his mood. Streets, shops, a picturesque floor show, life in the town all interested him more than the splendor of their historic works of art." Yet he would sometimes sit for hours with great enthusiasm in front of a picture in a museum. On other occasions he would rush through whole rooms without taking a closer look at a single picture. In Holland, it was mainly Rembrandt and Frans Hals that interested him for their brush techniques. His special predilection was also for the Spanish painters Goya and Velasquez. Nevertheless, there is hardly any direct trace in his work of the pictures he saw on his travels.

Rembrandt
Self-portrait, 1648
Etching
15.7 x 12.8 cm
London, British
Museum

Graphic artist
Adolphe Albert, 1898
Lithograph
34.3 x 24.5 cm
Paris, Bibliothèque
Nationale

The adaptation of a self-portrait by Rembrandt for a lithograph of the engraver Adolphe Albert (1865–1928) is a rare phenomenon in the oeuvre of Toulouse-Lautrec. Commissioned by Maurice Joyant, the picture is immediately noticeable for its chiaroscuro effects and unusual precision of detail. Toulouse-Lautrec owed Albert his first chance to exhibit in the Salon des Indépendants in 1889 and from 1893 in the Salon des Peintres-Graveurs.

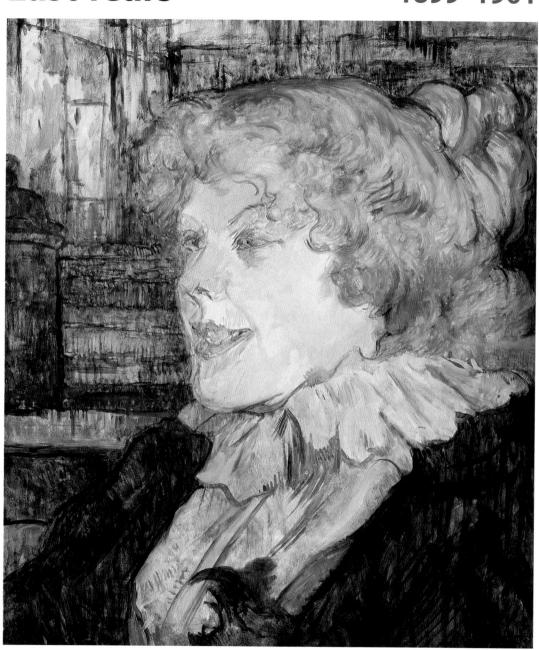

After his initial artistic successes Toulouse-Lautrec experienced a mental and physical crisis. Forced hospitalization at the psychiatric clinic in Neuilly brought home to him the full gravity of his situation. In despair, he sought to prove that he was still an artist to be reckoned with. After being discharged on May 20, 1899, despite the restrictions imposed by his maladies he continued until his death to produce works that showed consistent development from his existing oeuvre. Yet he did not have enough time to transmute all his new ideas into pictures.

As the health of the artist rapidly deteriorated during the winter of 1900–01, he put his artistic legacy in order and finally returned to his mother's house.

On September 9, 1901, Toulouse-Lautrec died at the Château de Malromé in the presence of his parents and his cousin Gabriel.

Alfred Nobel
ca. 1895–1896

The last photo of Toulouse-Lautrec

1900 Boxer uprising in China. Commissioning of the first stretch of the Paris Metro, to the World Exposition. The Civil Code comes into force in Germany. Sigmund Freud publishes *Traumdeutung* (Interpretation of Dreams), the founding work of psychoanalysis.

1901 Death of Queen Victoria. First Nobel Prize awarded, having been founded in 1895 by industrialist and inventor Alfred Nobel. Theodore Roosevelt becomes President of the USA (until 1909).

1899 After a breakdown, Toulouse-Lautrec is shut away in a psychiatric clinic from late February to mid-May

1900–1901 In Bordeaux from October 1900 to April 1901.

1901 He leaves Paris in July 1901 and returns to the resort of Taussat in the south of France, where he has a stroke on August 15 that paralyses one side of his body.

1901 Toulouse-Lautrec returns to Malromé on August 20.

1901 He dies in Malromé on September 9.

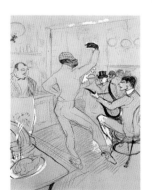

Opposite:
The English girl from the Star in Le Havre (Miss Dolly), 1899
Oil on wood, 41 x 32.8 cm
Albi, Musée Toulouse-Lautrec

Right:
Chocolate dancing, 1896
Drawing, 65 x 50 cm
Albi, Musée Toulouse-Lautrec

An Artistic Resumé

Towards the end of his life, Toulouse-Lautrec's work underwent a change of style. The garish colors and vigorous hatchings in his paintings gave way to denser, calmer applications of paint. Where before 1900 a tendency was evident towards smaller pictorial sections with fewer people and a more personal note in the characterization of people, a different mood now prevailed in the choice of section and lighting of the pictures. Possibly, with growing artistic maturity

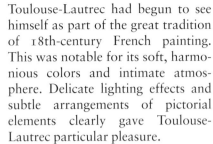

Séparée in the Rat Mort, 1899
Oil on canvas
56 x 46 cm
London, Courtauld Institute Galleries

This painting shows Lucy Jordan, a well-known figure of the Parisian *demi-monde*, in a fashionable restaurant at the turn of the century called the Rat Mort. Unfortunately, we do not know who La Jordan's male companion was at this intimate supper.

Toulouse-Lautrec had begun to see himself as part of the great tradition of 18th-century French painting. This was notable for its soft, harmonious colors and intimate atmosphere. Delicate lighting effects and subtle arrangements of pictorial elements clearly gave Toulouse-Lautrec particular pleasure.

Even though the portrait of the courtesan Lucy Jordan in male company in the chic Rat Mort (Dead Rat) restaurant is not 18th-century oriented in subject matter, an echo of the style is manifest in the details and lighting effects. In its technical virtuosity, the still life in the foreground of the painting harks back to the most celebrated of rococo still-life painters, Jean-Baptiste Chardin (1698–1779), while the brush technique and distribution of light are reminiscent of Jean Honoré Fragonard (1732–1806). Both the subject matter and ruthless artist's eye remain firmly in the Toulouse-Lautrec style.

A picture from the following year carries still more powerful echoes of the 18th century. Through his friend Adolphe Albert (pp. 78–79) Toulouse-Lautrec had got to know Renée Vert, who owned a milliner's shop. Probably at her prompting, he painted several pictures on the subject of fashion. *The Milliner* is the most remarkable of the series, because Toulouse-Lautrec transmutes the picture of the young woman absorbed in her work into a portrait and milieu study. The subject, Louise Blouet, Toulouse-

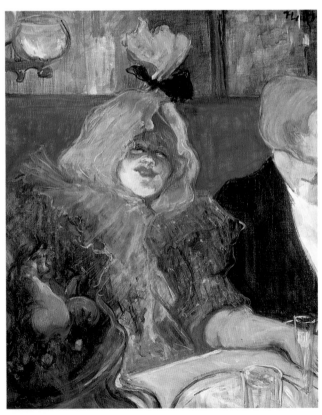

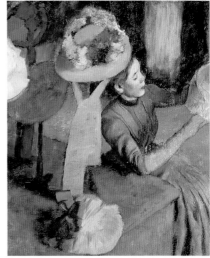

**The Milliner:
Mademoiselle
Louise Blouet**, 1900
Oil on wood
61 x 49.3 cm
Albi, Musée Toulouse-
Lautrec

In the tradition of an
18th-century
domestic scene
showing a woman at
her needlework,
Toulouse-Lautrec
develops a repose
and intensity of
representation
hitherto unknown.

Lautrec used to call *La Croquesi-Margouin*, a pun on *croquer*, which means means both "to sketch" and "to gobble up".

Leclercq says of the relationship: "with her, Lautrec was like one child with another. They got along." Toulouse-Lautrec esteemed the young woman so highly that he said a special good-bye to her when he left Paris mortally ill; "We can hug each other because you won't see me again. When I am dead, I shall have Cyrano's nose." As the quotation shows, Henri de Toulouse-Lautrec retained almost to the end his mocking style in his manner with other people. In his last pictures, which have lost their sectional character and contain virtually no movement, that mockery is no longer there.

Liberated by Art?

In the late 1890s, Toulouse-Lautrec became increasingly tyrannical and irritable in his behavior. An attack of *delirium tremens* in 1897 was the first dramatic harbinger of his progressive alcoholism. Symptoms of paranoia such as a fear of microbes also set in, causing him to spray his room with benzene. These developments came to a head when he collapsed in the street at the end of February 1899, breaking a collar-bone.

As his mother was tending her own mother in the south of France, she instructed her housekeeper to keep her informed about her son's health. As a result, we have reports about the course of his illness that show that he was in a bad way and his behavior was no longer socially acceptable. Unfortunately, Toulouse-Lautrec's subsequent admission to a psychiatric clinic in Neuilly at the instigation of his cousin Gabriel and his friend Dr. Bourges gave rise to malicious and inaccurate reports in the papers about the artist's supposed mental illness.

How desperate Toulouse-Lautrec felt is clear from an appeal he addressed to his father from Neuilly: "Papa, you have a chance to behave humanely. I am incarcerated, and those who are robbed of freedom perish!" But his father, who was quite indifferent to the problem of alcoholism, rejected his son's plea to be released from the clinic – upon which Toulouse-Lautrec developed a strategy to prove his mental soundness. In order to obtain permission to leave the clinic, he drew from memory chalk drawings on circus topics, about which he himself said: "I bought myself out with my drawings." The circumstance is significant in that, of necessity, for the first time Toulouse-Lautrec had to work without a model, which explains the unreal character of the drawings done while in the sanatorium.

After the artist had obtained his release with the aid of his pictures, the roué, retired admiral and distant relative Paul Viaud was engaged as a constant companion to keep him

At the circus: the female clown comes on, 1899
Colored chalk on white paper
35.6 x 25.4 cm
Cambridge, Fogg Art Museum

This painting shows the famous female clown Cha-U-Kao, or Chahut-Chaos, whose name was derived from 'noise chaos', on a pony refusing at the entrance to the ring, which is shown with just a few strokes of chalk.

Henri de Toulouse-Lautrec as a clown, photo ca. 1894

Even dressed up as a clown, Henri de Toulouse-Lautrec displays a talent for parody and incongruity. The pince-nez on his nose, in combination with the grave expression, minimises the comic effect.

from drinking. The latter took to presenting Viaud as "Monsieur Viaud, my bear leader, a ruined man of the world." Toulouse-Lautrec, nonetheless, found no difficulty in tricking his companion. He had a hollow stick made in which he was always able to carry a reserve of alcohol. His disregard for the doctors' instructions – a condition of his leaving the clinic – further undermined his already fragile health. Despite regaining his creativity, Toulouse-Lautrec had lost his zest for life.

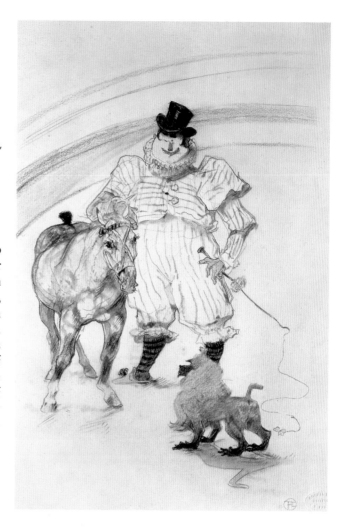

At the circus: horse and monkey training, 1899
Black chalk, colored pencils, lead pencil on paper
44 x 26.7 cm
Private ownership

The strange character of the scene is due to its isolation from the context. The artist lays out the three figures on the paper like a laboratory assistant, only the curved lines in the background indicating the place, i.e. the circus ring. The juxtaposition of the animals and the masked face of the clown generates tension without giving a clue as to the further development of events. Besides the subject matter, of note is the artist's choice of color.

Joyant – Promoter and Friend

Maurice Joyant (1864–1930) had been in Toulouse-Lautrec's class at the Lycée Fontanes in Paris, but they lost contact with each other after Toulouse-Lautrec returned to the south of France. Joyant had been trained in law, but after the death of his father decided to throw in his safe job at the ministry and enter the art business.

An opportunity came up in 1890 when Theo van Gogh fell victim to severe depression after his brother Vincent's suicide, and affairs at the branch of Galerie Goupil that he had managed since 1886 were in a state of disarray. The owners, Comte de la Goupil and his sons-in-law, were horrified at the number of modern pictures that van Gogh had bought – more from commitment to modern art than on commercial judgment – and asked Maurice Joyant to save the situation. Joyant succeeded in placating the owners without prejudicing the progressive reputation of the gallery.

Meanwhile, Joyant and Toulouse-Lautrec had met up again and were as close friends as in their

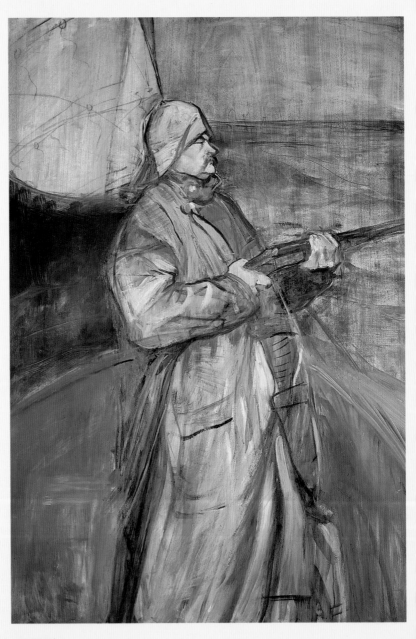

Maurice Joyant duck hunting, 1900
Oil on wood
116.5 x 81 cm
Albi, Musée Toulouse-Lautrec

Lautrec painted frightening pictures without nightmares or illusions ... and with the determination to tell the whole truth

Gustave Geffroy in *Le Journal*

Maurice Joyant, photo ca. 1899

schooldays. Joyant admired his friend's art, and in 1893 arranged for him to have his first one-man show at the gallery he managed – though it became, at Toulouse-Lautrec's request, a joint affair with the graphic artist Charles Maurin. The show brought together around 30 of Toulouse-Lautrec's works. After he had taken over the gallery entirely in 1897, Joyant was able to promote his friend more intensively, and took charge of all his one-man shows in Lautrec's lifetime. The biggest one-man show, which was even visited by the Prince of Wales, took place in May 1898 in the London branch of Goupil, with 78 works on show. Although Toulouse-Lautrec also sold his pictures through the renowned Bing and Durand-Ruel galleries in Paris, Joyant's credit is to have added friendship to promotion – as a result of which a wholly different relationship of trust ensued between gallery owner and artist. It was for this reason that Joyant was entrusted by Toulouse-Lautrec's

parents with the inspection and evaluation of the painter's legacy of works. During the crisis in Toulouse-Lautrec's mental and physical health, Joyant tried to obtain commissions for him from members of Parisian society, to keep him busy and to stop him drinking. The plan failed because of the painter's lack of interest and unwillingness to flatter the clients in his pictures. Joyant was also among the few who opposed Toulouse-Lautrec's enforced incarceration in a psychiatric clinic, as he feared much

greater harm from interning the freedom-loving artist than from his drinking.

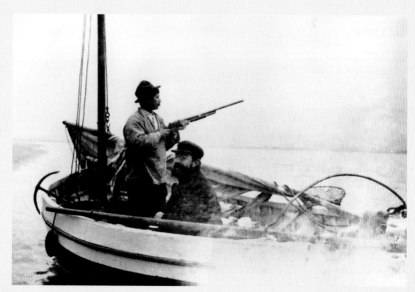

Maurice Joyant and Toulouse-Lautrec hunting duck, photo ca. 1899

Lost Happiness – Despairing of Life

After his spell in the clinic, the rapid deterioration in his health accelerated in March 1901, when Toulouse-Lautrec was in Bordeaux with Viaud. Afflicted by premonitions of imminent death, he dragged himself back to Paris with great difficulty, to deal with jobs he had left undone and to complete unfinished works. He used the opportunity to say good-bye to his friends, combed through his studio and destroyed numerous works that did not meet his demand for perfection. He wanted to determine for himself which of his works should remain preserved for posterity.

Even so, he still painted new pictures, including the medical exam of his cousin, Gabriel Tapié de Céleyran. This picture may be regarded as a legacy to the tireless, loyal companion who stood by him during the crisis at the end of his life. It is supposed to be Toulouse-Lautrec's last picture, completed with rapidly dwindling strength, before the doctor in Malromé, where he had

Admiral Viaud, 1901
Oil on canvas
139 x 153 cm
São Paulo, Museu de Arte Assis Châteaubriand

In his late works, Toulouse-Lautrec increasingly adopts the palette and intimate mood of 18th-century French art. In this picture, which the artist painted for the dining room of the Château de Malromé, he shows Paul Viaud, a relative and retired admiral. Viaud was Toulouse-Lautrec's constant companion after the painter was discharged from the psychiatric clinic at Neuilly, and in this picture is shown wearing historic costume. Of note is the change in painting technique towards a flatter covering of the canvas instead of the typical hatching. Possibly, however, it just indicates that the picture is not finished.

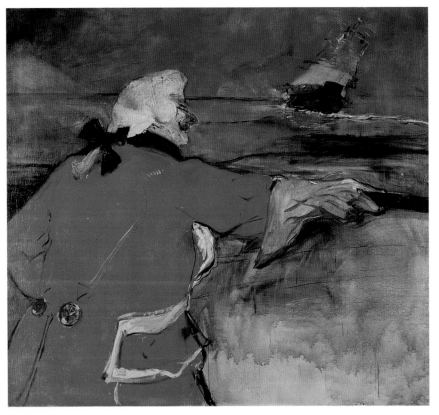

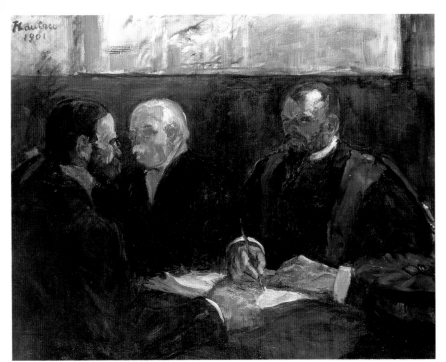

An exam at the Medical Faculty in Paris, 1901
Oil on canvas
65 x 81 cm
Albi, Musée Toulouse-Lautrec

Toulouse-Lautrec's cousin Gabriel passed his medical exam on March 15, 1899, but the artist could not be present because he was then already at the psychiatric clinic. The unusual subject and design betray a new artistic development: a reduction in the palette and denser application of paint generate a newfound well-roundedness.

returned in August 1901 to die, forbade him to paint. The attacks of feebleness and paralysis he experienced had become more frequent, and made even drawing an effort.

He told his mother: "I know I have to die. Even just a few weeks ago I didn't want to say that dying is where it's headed. I was afraid to over-alarm you with it. But you've realized it yourself now. So that's all right. How nice you can make me tea as often as you like at last."

Toulouse-Lautrec in the garden of the Château de Malromé, photo, summer 1900

The photo shows the artist about a year before his death. The rapid physical deterioration of Henri de Toulouse-Lautrec is not yet evident from the photo, which reflects the rural idyll of Malromé.

In 1901, Toulouse-Lautrec retired completely to his parents' country house, as life in the metropolis of Paris gradually began to overtax him.

After Toulouse-Lautrec

Despite the brevity of his life, Toulouse-Lautrec had a decisive influence on the next generation of artists. His artistic achievements spurred, above all, Pablo Picasso and Fauvists such as André Derain and Henri Matisse to creations of their own. His often garish color, his detachment of color from object and the distancing achieved by his use of unusual colors enabled the still largely traditionally trained young artists to develop their individual styles. The flat three-dimensionality and other Japanese stylistic effects in Toulouse-Lautrec's work opened up new design opportunities for the next generation.

The Fauvists were interested mainly in the simplified composition of the pictures and in overcoming the dissection of color pursued by the Impressionists. They used color in pure tones as an autonomous feature of design that was no longer oriented to reality. Also, like Toulouse-Lautrec, they left the light, rough ground of

the canvas partly unpainted, which gives their pictures a particular effortlessness. Thanks to the diffusion of Toulouse-Lautrec's work in the form of lithographs, artists who did not live in Paris and could rarely see oil paintings by him could also become familiar with it. But even Paris-based artists such

as Picasso, who owned a copy of the *May Milton* poster (see page 51), and the Cubist painter Georges Braque admired the lithographs. Braque waited in the street until the bill-poster had put up a poster by Toulouse-Lautrec, then immediately removed it and stuck it on the wall of his

room. The easy transport and relatively cheap reproduction of graphic work in periodicals also contributed to the growing familiarity with Toulouse-Lautrec both at home and abroad.

An affinity of subject matter with Toulouse-Lautrec is particularly evident in

Pablo Picasso
Les demoiselles d'Avignon,
1907
Oil on canvas
243.9 x 233.7 cm
New York, Museum of
Modern Art

In Paris I understood what a great painter Lautrec was.

Pablo Picasso

Picasso's *Les demoiselles d'Avignon*, with its echoes of brothel scenes from the previous century. However, this seminal work of Cubism has clearly moved on from the approach of Toulouse-Lautrec's painting. The dissolution of bodies into geometric forms foreshadows a multi-aspect, three-dimensional approach. The typical silhouetted character of Toulouse-Lautrec's figures is discarded. Nonetheless, Toulouse-Lautrec left a decisive mark on Picasso's Blue Period style (1901-1904). Picasso adds to the topics from city life such as scenes from bars and dance halls a sad, socio-critical undertone marked by his own hard life. Just as Toulouse-Lautrec developed Degas's subject matter in his own way, so in the new century the image of the city that Toulouse-Lautrec had seen underwent a change in Picasso's hands.

Henri Matisse
Portrait of Madame Matisse, 1905
Oil on canvas
40.5 x 32.5 cm
Copenhagen, Statens Museum for Kunst

André Derain
The dancer, 1906
Oil on canvas
100 x 81 cm
Copenhagen, Statens Museum for Kunst

Glossary

abstraction Ignoring naturalistic (i.e. nature-copying) representation to the point of completely dispensing with the representation of objects.

art nouveau Art style from around 1900. Called *Jugendstil*, or Secession style in its German and Austrian form. Notable for its linear, ornamental/decorative approach.

avant-garde French for "vanguard". Term for artistic groups or artistic statements that are in advance of their time, go beyond what already exists and anticipate trends.

bohemian Originally a description for gypsies (from Bohemia), later mainly for artistic circles that consciously set themselves apart from bourgeois society. The term used in this way is documented in Paris from about 1830, among the first "Bohemians" being the writers Théophile Gautier and Gérard de Nerval.

contour Outline of a shape drawn as a line or by means of contrast.

contrast Marked differentiation. In painting, distinction is made between contrasts of light and dark; color, warm and cold, complementary or simultaneous.

color perspective A tool for depicting perspective that creates three-dimensionality and depth by the different spatial effect of cold and warm colors.

composition Fitting together and pictorial structure generally. Refers to the construction of a work of art, i.e. the artistic formulation of the relationship between pictorial content and the visual form of a painting.

crachis technique Process involved in lithography, in which splashes are applied to the stone with a brush and metal net. The process serves to bring out shading and soft transitions between various colors. From French for "spittle".

Cubism Style developed by Pablo Picasso and Georges Braque (from around 1907) in which objects are reproduced not according to their optical effect but by being broken down into geometric forms. A distinction is made between "analytical Cubism" (up to ca. 1911) and "synthetic Cubism" (1912 to mid-1920s).

drawing Preparation for a painting or sculpture, that can also be an independent work of art. Reckoned to be a direct transfer of an artistic idea into a visual medium.

etching Gravure technique like the principle of engraving but simpler to handle, as the printing plates are made of softer metal.

Fauvism From the French *fauves* meaning wild animals. Loosely associated group of artists that developed around Matisse in 1905 in opposition to the Impressionists' dissection of color. They used pure, unbroken colors in their pictures, ignoring the accuracy of depiction. From 1900, André Derain and Maurice de Vlaminck, working from the basis of van Gogh's painting, developed the principle of strong coloration combined with simple composition. The most important representative of the style, which gave way to Cubism in 1907, was Henri Matisse.

gouache Painting technique using water-based paints that, unlike water colors, are not transparent but remain opaque when they dry. By adding binders and opaque white, a pastel color effect is produced with a brittle surface.

history painting Representation of historic events and mythological or Biblical/religious themes which are depicted either true-to-life or with exaggerated idealization. Up to the end of the 19th century, history painting (also called the "grand manner") was considered the highest form of painting, ahead of lower forms such as portraits and still less valued genres such as landscape, genre (everyday life) painting and still lifes.

homage Can be effected in written or visual form, either by quotation from other artistic works or by the focused adaptation of a particular subject matter.

Impressionism Developed around 1870 from the open-air painting (as opposed to studio painting) of the Barbizon School. The name came from Claude Monet's painting *Impression - soleil levant* exhibited in 1874. The Impressionists' principal concern was to reproduce an object or landscape in the momentary effect of natural light. To achieve this, color was broken into its individual components and contours were dissolved. Impressionism gained the upper hand over conventional art created solely in the studio.

japonisme Refers to the influence of Japanese art on the Impressionists and later styles such as *art nouveau*. An emphasis on line, the flat echeloning of individual pictorial surfaces and an intensive coloration are the main features of this style.

landscape painting Representation of pure landscapes. Though initially landscape was an accessory for filling in background, by the end of the 16th century it had developed into an independent genre. The 17th century created the "ideal" landscape (e.g. Claude Lorrain's

transfigured landscapes) and "heroic" landscape (e.g. Poussin). Landscape painting reached its apogee in the Dutch baroque. Revolutionised in 19th century by the emergence of open-air (*plein air*) painting.

life class Drawing class for art students using a nude model.

linear perspective See *Perspective*.

lithography Form of printing using stone plates, developed by Alois Senefelder ca. 1796, in which the parts to be printed and not to be printed are on a single level. See pages 46–47.

oeuvre The total output of an artist.

oil painting Paint medium in which the paint pigments (pulverised colors) are bound with oil. Oil paint is malleable, dries slowly and can be easily mixed with other oil paints. Oil painting emerged in the 15th century, since when it has been the dominant medium of painting.

palette Painter's [hand-held] board, usually oval or kidney-shaped, on which paints are mixed. In a figurative sense, it refers to the range of colors used by an artist.

perspective [Lat. *perspicere*, penetrate by looking] Representation of objects, people and spaces on a pictorial surface, as a result of which an impression of spatial depth is created by graphic and painterly

means. Perspective was discovered in the Renaissance period by science and applied to painting. In central perspective, the parallel lines running into the depth of the picture (i.e. the horizon) meet at the vanishing point (linear perspective or vanishing point perspective). Objects and people get smaller proportionally to distance in accordance with the grid produced by the perspective lines. A further way of producing depth in a picture is color or aerial perspective, under which the things represented lose color intensity as the distance increases and the color changes into bluish tones.

portrait Representation of a person in a painting. Types of portrait include self-portraits, single portraits, double portraits and group portraits.

printed graphics Collective term for sundry graphic techniques used in printing such as woodcuts, copper engraving, etching, lithography or silk screen. All these techniques allow works of art to be reproduced.

profile Side view of a figure that particularly emphasizes the outlines of the face, brings out the characteristics of forehead, nose and chin and sets them off against a background.

proportion Weighting of individual elements within a picture.

self-portrait A picture of an

artist by the same artist.

still-life Genre of painting in which lifeless things such as fruit, dead animals, flowers or everyday objects are depicted. Still lifes often have symbolic character. They flourished particularly in Dutch painting in the 17th century as a "lower" genre in the academic hierarchy of art.

subject The basic idea or content of a painting; what is represented.

tempera [Ital: *temperare*, to mix] Painting medium used in Middle Ages and Renaissance prior to the arrival of oil painting. The binders of tempera paints are thinned in water, but after application the paints are no longer soluble in water.

watercolor Water-soluble colors that dry transparent, i.e. they do not cover what is underneath, and are therefore delicate and easy to work with.

Index

Acknowledgments

The publishers would like to thank all the museums, photolibraries and photographers for allowing reproduction and their friendly assistance in the publication of this book.

© Graphische Sammlung Albertina, Vienna: 47 t.

© Archiv für Kunst und Geschichte, Berlin: cover, 2 (photo: Maurice Guibert), 5 tr/tl, 7 tl, 9 t, 10 t, 15 tl, 16 t/b, 20 t, 21 b, 23, 24, 25 tl, 30 b, 38, 39 tl, 40 t, 41, 42 r, 45 b, 49 tl/b, 51 r, 61 tl, 63, 64 b, 66, 67 b, 69 t/b, 71 tl, 74 t, 76 r, 77 l, 81 tl/b, 82, 90; (photos: Erich Lessing) 30 t, 36 l, 65 t, 83 r/l

© Artephot/Coll. Sirot-Angel, Paris: 28 b

© Arthothek, Peissenberg: 36 r; 13 t (photo: Joseph S Martin), 40 b (photo: Jochen Remmer), 29 t (photo: Peter Willi); (photos: Hans Hinz) 27, 35; (photos: Joachim Blauel) 5 bl, 17 t, 70; (photos: Christie's) 73, 78 t

© Bibliothèque nationale de France, Paris: 11 l, 79 t.

© Bildarchiv Preussischer Kulturbesitz, Berlin 1999: (photos: D Katz) 45 t, 46 b, 59 l, 77 r.

© Bridgeman Art Library, London: 4 br, 13 b (Lauros-Giraudon/BAL), 31 r, 37 t (Giraudon/BAL), 43 l, 52 t, 54 t, 55 (private collection of Mrs John Hay Whitney, New York), 58 tr, 60, 65 b, 68 tr/tl, 71 b, 72 t, 74 b, 85 r, 89 t, 91 l.

© British Museum, London, Trustees of: 79 b.

© Brooklyn Museum of Art, New York: 22 t.

© Carnegie Museum of Art, Pittsburgh; acquired through the generosity of the Sarah Mellon Scaife family: 31 l.

© Courtesy of the Fogg Art Museum, Harvard University Art Museums, bequest of Frances L Höfer: 84

© J Paul Getty Museum, Los Angeles: 56 t.

© Collection Kharbine-

Tapabor, Paris: 25 tr, 43 r, 57, 71 tr

© 1999 Metropolitan Museum of Art, bequest of Miss Adelaide Milton de Groot (1867–1967), New York: 62 l.

© Musée des Augustins, Toulouse-Cliché STC – Mairie de Toulouse: 32

© Musée Toulouse-Lautrec, Albi: 4 tl/bl, 5 br, 6, 7, tr/b, 8 r/l, 9 b, 10 b, 11 r, 12, 15 tr/b, 18 t/b, 19 r, 21 t, 22 br, 25 b, 26 b, 33 b, 34, 39 tr, 48, 49 tr, 56 b, 61 tr/b, 62 r, 75, 76 l, 78 b, 80, 81 tr, 85 l, 86, 87 t/b, 89 b, back cover

© Museu de Arte de São Paulo, Assis Châteaubriand: 64 t, 88

© 1999 Board of Trustees, National Gallery of Art, Washington: 54 b.

© Ny Carlsberg Glyptotek, Copenhagen: 33 t.

© RMN, Paris: (photos: Arnaudet) 4 tr, 14; 19 l (photo R G Ojeda); 37 b (photo Jean Schormans), 39 b.

© Scala, Florence: 50 l.

© Smith College Museum of Art, Northampton, gift of Selma Erving, class of 1927, 1978: 47 b.

© Statens Museum for Kunst, Copenhagen: 91 r (photo: Hans Petersen)

© Thielska Galleriet, Stockholm: 17 b.

© Roger-Viollet, Paris: 20 b, 22 bl, 26 t, 28 t, 44 r, 50 r, 51 l, 58 tl, 67 t, 68 b, 72 b.

© Jane Vorhees Zimmerli Art Museum, Rutgers, State University of New Jersey, New Brunswick: 44 l. (photo: Victor Pustai)

Key
r = right l = left
t = top b = bottom
c = center

© 1999 Könemann Verlagsgesellschaft mbH
Bonner Strasse 126, D-50968 Cologne

Editor: Peter Delius
Cover design: Peter Feierabend, Claudio Martinez
Concept, editing of the original edition and layout: Jana
Hyner
Picture research: Jens Tewes, Holger Pingel
Production: Mark Voges
Lithography: Digiprint GmbH, Erfurt

Original title: Henri Toulouse-Lautrec

© 1999 Könemann Verlagsgesellschaft mbH
Bonner Strasse 126, D-50968 Cologne

Translation from German: Paul Aston in association with
Goodfellow & Egan
Editing: Susan Fenton in association with Goodfellow & Egan
Typesetting: Goodfellow & Egan
Project management: Jackie Dobbyne for Goodfellow & Egan
Publishing Management, Cambridge, UK
Project coordination: Nadja Bremse
Production: Ursula Schümer
Printing and binding: Sing Cheong Printing Co. Ltd.
Printed in Hong Kong, China
ISBN 3-8290-2933-0

10 9 8 7 6 5 4 3 2 1

Cover:
**La Goulue enters the Moulin Rouge
with two women**, 1892
Oil on card, 79.4 x 59cm
New York, the Museum of Modern Art

Illustration:
**Monsieur Toulouse paints
Monsieur Lautrec-Monfa**,
photo montage
ca. 1890 by Maurice Guibert

Back cover:
Henri Toulouse-Lautrec in 1889, photo